Confederate Jasmine
and the Fat Tuesday Tree

MILKWEED

ASCLETIAS SYRIACA

*found blowing near a
tent revival*

Confederate Jasmine
and the Fat Tuesday Tree

A POETIC HERBARIUM

Ann Lewis

CHRONICLE BOOKS

SAN FRANCISCO

This work is a fictionalized memoir, and some names of persons and places have been changed.

Library of Congress Cataloging-in-Publication Data:
Lewis, Ann.
 Confederate Jasmine and the Fat Tuesday tree : a poetic Herbarium / by Ann Lewis.
 p. cm.
 ISBN 0-8118-1308-8
 1. Southern States—Social life and customs—Fiction. 2. Botany—Southern States—Fiction.
I. Title.
PS3562.E92787C66 1997 96-44576
813'.54—dc21 CIP

Printed in Hong Kong

Illustrations/art by Ann Lewis
Art photographed by Sibila Savage
Book and cover design by Pamela Geismar
Calligraphy by Pete Friedrich

Distributed in Canada by
Raincoast Books
8680 Cambie Street
Vancouver, B.C. V6P 6M9

10 9 8 7 6 5 4 3 2 1

Chronicle Books
85 Second Street
San Francisco, CA 94105

Web site: www.chronbooks.com

CONTENTS

GRAPE VINE

VITIS VINIFERA

Introduction

*W*hat is a poetic herbarium? Why the Deep South? What is the connection between the art and the writing? Is this fiction or nonfiction? What am I getting at? Don't fret. I'll explain.

A traditional herbarium is defined by the *Micropedia Britannica* as "a collection of a few to many thousands of dried plant specimens mounted on sheets of paper. The species thus mounted have been identified by experts and labelled by their proper scientific names, together with information on where they were collected, how they grew, and so on. They are dictionaries of the plant kingdom." So what then is a poetic herbarium? Consider *Confederate Jasmine and the Fat Tuesday Tree* a loose dictionary of the plant and human kingdoms. I offer an artist's and writer's fictionalized view of a place near and dear to my heart. I have roamed around the South for reasons I will elaborate upon soon enough, and mused upon the landscape and the people.

Whenever people travel, they move through the land. We look out the window at the scenery, walk around, take in the sights and smells. We watch each other, and chat casually with fellow travelers or the locals. We gradually get to know a place both through our senses and through encounters with people. The art and the writing in *Confederate Jasmine and the Fat Tuesday Tree* serve as another kind of window, looking out (or looking in) to the Deep South.

Why the South? To answer that, let's take a side trip to Demopolis.

Grapes and olives. Not crops you would expect in the southeastern United States. Maybe you see in your mind Greece or the south of France, but not the Black Belt of Alabama, home of cotton fields, cement factories, paper mills, limestone bluffs, a lock and dam, catfish. But the Napoleonic exiles who emigrated to what is now known as Demopolis (Greek for "City of the People") thought they'd make a go of raising Mediterranean crops. They arrived in this region around 1817, wearing their elegant French clothing, carrying land grants in their luggage. They'd come by barge upriver to claim their land, but due to the difficult passage and general confusion, they several times began settlements in the wrong spot. When they finally made it to their assigned parcel of land, they planted exotic seeds and waited for home to recreate itself. The exiles were aristocrats and knew very little about farming, especially in unsuitable canebrake soil. The women, it is said, planted and milked in their ball gowns while the men cleared land in their fine French military uniforms. No good water or wagons, conflicts with locals, little good farming sense, and pitiful crops forced the French to give up and flee to Mobile and New Orleans. Some even returned to a more hospitable, postrevolutionary France. Though the enterprise failed long ago, the name The Vine and Olive Colony is still hitched to Demopolis. You can find a few olive trees in town, but whether they are progeny of the aristocrats is unclear. Grapes have probably lingered on wild.

The idea of a French influence in Demopolis is appealing. Maybe the schools would have been bilingual. Everyone would have elegant clothing and gorgeous skin. We might have refreshed ourselves in the sweltering heat with Pastis or Orangina instead of Coke or iced tea (though I like iced tea). The bakery would sell chewy baguettes and madeleines instead of white bread and pecan pie (though I like pie, too). The cuisine would center on the local savory cornucopia of olives and grapes, not pizza or fried fish or barbecue (though of course I've enjoyed my share of these foods, as well).

Demopolis may not taste like France—few places do—but for me it has a unique charm. Where else could I go into the drugstore and have an old man pipe up from his table of coffee-drinking buddies, "You Ralph Lewis's girl? He was quite a ball player. I remember a home run he made in a high school baseball game in 1948 . . ." He'd never seen me before, but he recognized the Lewis in me. More so than I do. When my Grandaddy Lewis died, all the men in the streets tipped their hats to him as the hearse drove by. And there was the blind man who came shopping at the store where my cousin, George, worked. When George asked if he could help the man, whom he'd never seen before, the man said "You must be Archie Patterson's kin," recognizing my mother's family in only a few words. This is belonging somewhere, even if you don't think you do. This is the town that has held me fast to the South. The place that has spawned many a dinner conversation, many a reminiscence in my family.

I was raised by southern parents—high school sweethearts from Demopolis. Demopolis became for me a mysterious but intimate locus, a second home to which we made regular visits. While my friends up north were saying "You guys" and "sneakers" and "Mom and Dad," I was raised on "Y'all" and "tennis shoes," "Mama and Daddy," "Yes, sir and Yes, ma'am." We greazed—not greased—our baking pans; we ate biscuits and fried chicken and even the occasional pork rind. (I once served pork rinds to a kosher friend not having any idea that they were *really* pork!) My friends' parents were from New York, Boston, Philadelphia, Ohio. We were that family from down yonder.

We moved north when I was seven. My father was transferred from east Texas, which counts as the South as far as I'm concerned, and was going to work in New York City. We were to live in Connect-i-cut, the state with as many letters as Mississippi. It was 1969. When we stopped for gas in New York City, I saw my first hippie; the gas station attendant had a ponytail halfway down his back and was wearing a pullover muslin Indian shirt. Surely he

didn't have on those flat leather sandals with the separate big-toe holder, not in a gas station, but I remember him that way. He cleaned the windshield but didn't smile. I stared, afraid because he was the opposite of what I knew. My father had short, short hair and dark-rimmed chemical engineer's glasses. He was tidy and graceful and said "please" and "thank you" smooth as butter. My mother had lightly teased hair, wouldn't dream of letting it hang stringy, wouldn't wear beads or low-slung bell-bottoms. She wore a double knit pantsuit she'd more than likely made herself. She had two daughters—one tow-headed, the other red—each reaching for her over the large Pontiac seat. "Did you see him, Mama? Did you see?"

Huge stalks of sumac, large masses of rock between which the grimy freeway lay, the city smells, the traffic; where were the chameleons, the mimosa and bottle brush trees, the flat, flat fields of home? We continued north to Connecticut, where winding roads and stone walls and old houses were a welcome sight. We arrived at our antique cape behind one of those walls. We discovered bleeding hearts and lady's slippers, Jack-in-the-pulpits and two hundred-year-old maple trees, even a Japanese ginkgo tree, surrounding us. The landlord left us a hen that laid spotted eggs. Come winter, we saw snow for the first time. We were thrilled and wide-eyed at all these changes. My southern accent drifted off as I started first grade with the Yankees (it resurfaces at odd moments as I grow older—certain expressions, a slight lilt at the end of a sentence). Time passed and I eventually became what my high school physics teacher called the Last Hippie, suburban style. My hair was long and stringy, I ate lentil soup and dreamed of a peaceful, happy world in which everyone was equal and everyone put their pants on the same way. I didn't say "Mama" anymore, but "Mother." I just didn't know how to say "Mama" up north. I've often thought this change of endearments separated me even more than geography from my southern roots. Now, if it didn't seem so contrived, I'd like to say "Mama" again. Is it too late?

COMMON FIELD SORREL

RUMEX ACETOSELLA

My family spoke in exaggerated southern accents around the house. We made endless fun of bad TV and movie accents, of *Hee Haw* characters and Gomer Pyle. Florence Henderson's Shake 'n' Bake commercial has a permanent place in our family patter—something about the wretched accent Florence uses when she says "I made it with Shake 'n' Bake" and then the stupid-sounding daughter who chimes in "And I helped!" We have drawn the word "helped" out to six or seven syllables and attached this phrase to completely unrelated events. When someone buys new shoes, for example, someone else chimes in "And I helped!" But I realized there was a difference in the way we played around with accents and the way other people did. You can make fun of your own family or region, but whoa if someone else does. Same with your ethnicity, your religion, and your home. People would look askance when we spoke, assume we were simpletons, that we were affiliated with the KKK or were at least as bigoted as the next southerner. Other times people had no compunction about parroting us in bad southern accents, thinking it cute or just poking fun. If anyone imitates a native speaker from anywhere else, it is easily taken as a slight, but somehow everyone thinks its okay to do the southern thing. Recently, though, I have come to think of this habit as a form of flattery. After all, my friends, my family, and I just liked to play around with accents. It feels good. The sounds are playful, melodic, seductive, full of nuance. Southern accents leave plenty of elbow room. They can be beautiful; of course people want to try one on, not always out of jest, but in admiration.

After leaving Connecticut for Massachusetts, Texas again, California, and now Vermont, I began to revisit the South by trying to write a novel, and I soon realized I was stuck somewhere between the *Beverly Hillbillies*, Demopolis, and *Gone with the Wind*. I was stirring the same old blackened kettle of stereotypes. I needed to return to the South as an observer, as someone who kind of knew her way around, had plenty of experience with the rhythm of things, but who

wanted to look beyond the insular world of the family to see, as an adult, what else was going on in the South. So I traveled around, sometimes alone and sometimes with others. I spoke with southern friends, I read southern novels, history books, periodicals, I ate southern delicacies. I steeped myself in all things southern—so fully that I soon may have to pack up and move there.

I abandoned the novel along the way because *this* book was itching to be born; it is a collection of my recent and past impressions. In order to make this book, I crouched beside all kinds of plants to pluck the tiniest leaves and flowers I could find. I then hunkered over a table with tweezers to place each plant you see here in its own frame. I scribbled notes while sitting in hotels, on park benches, boat decks, and at kitchen tables; I pruned words for hours on end, trying to find a way to put some light in the windows, so to speak.

You may notice that I am drawn to unusual people. I by no means intend to insinuate that all southerners are oddballs, nor do I want to make sentimental or exotic caricatures of southerners. But the South *is* full of people who'll tell you just what they think in the most blunt or artful manner. These people are masters of the story—funny, articulate, and descriptive. They will use gesture and sound effects; nothing is spared to make the story work. If I have captured a fraction of this spirit or skill, I'll be happy. I know I have only dipped a toe into the South for there is a wonderfully varied and rich world to swim in down here. Go on. Look around. Wade in.

Daydream

I am in Demopolis, people-watching from a park bench that sits near the statue of a Confederate soldier who in turn sits in the middle of a rotary. As a child visiting my grandparents, I thought he was a real Confederate soldier whose actual remains were enshrined in the bronze casting. Now, I sit in his slightly creepy, familiar shadow and watch an old woman stringing laundry in the yard of her gingerbread-trimmed Victorian. Her floral housedress hugs her stooped shoulders like an afghan. Her old basset hound follows at her ankles while I daydream in my sleuth's notebook.

The basset hound, Ardmore, takes a padded bra from the basket of wet laundry waiting in the grass. The clothespins hang from a sack made to look like a small girl's dress and the woman reaches in without looking. After the laundry is hung, she will go back through the breezeway into the garage and get the homemade peppermint ice cream from one of two freezers, as long as flatbed trucks and as heavy. She will dish it out for herself and her family, sliding it into the bargain green-stamp bowls with decals of wheat in their bottoms. Everyone will sit in the metal lawn chairs in the shade and eye the wild grapes that have crawled up the side of the garage, just out of reach and daring to be picked. The sun blazes off the sheets that are so white on the wire clothesline as they ruffle in the breeze.

But just before the woman reaches into the sack for the last time, her dog with the low, thick torso, the stubby legs with skin roiling around his paws like flaccid gym socks, takes her Vanity Fair brassiere in his teeth and heads down the midline of the back yard, onto the gravel driveway, across the street, as she yells for him to come on home.

OLIVE

Olea europaea

On the way to die, because it's time, Ardmore crosses over the limestone canal that was dug by slaves. The stone is soft and you can see the carve marks that look like many, many spoonfuls of rice pudding scooped from a bowl of earth. Such painful shovel loads—did they work in full summer sun, the slaves? Did they have anything to drink, and how many died from the relentless pace? The canal circled the whole plantation, after all, and they couldn't stop until the water was released from the river. The canal was supposed to irrigate crops, I think—surely not those grapevines and olive trees that bore no fruit, in the end. Now the plantation is parceled off: a small Vanity Fair lingerie and leisure wear factory, a complex of cinder block apartments, a hospital, a hamburger stand, and the nicer homes, too; all live with the original, well-preserved house.

Ardmore, once over the wooden bridge, just past the iron sign commemorating the plantation and the ruling family (with a footnote about the slaves), comes to the house at the end of the road. It is a small wooden one that should be in Cape Cod, but here it is in Alabama with its bay windows and its winter white coat of paint. Ardmore turns right at this house and catches up with the canal in a bend where it widens and is bare for a moment in the sun before being swallowed up again by the fertile green algae that pours down its sides.

He crosses another bridge and sniffs warily at the edge. This one is rickety, fit just for foot traffic. It sags in the middle like a jungle bridge loping over deadly currents in the crook of some mysterious world. Anything could happen on the footbridge, somewhere between one road and another, a slippery route for the brave or the romantic. A canopy of evergreens and holly bushes hides Ardmore from view or rescue. But he makes it across—he doesn't want to die by falling—and comes out of the jungle at the old elementary school which was split down the middle by a fierce bolt of lightning forty years ago. Now he is on an old-fashioned main drag with chinaberry trees, an occasional odd olive tree, and that same flat-fingered grass, full of rude prickers, that grows all over town. He promenades down the sidewalk with the bra between his yellowed teeth. This street is full of big, old houses with porches

on three sides, balconies on the back. They are made of wood or brick and are trimmed with ironwork or Victorian gingerbread fringe, all with welcome mats. Welcome to look, maybe even come in.

He appears to be heading somewhere in particular—the marina? The lock and dam? The recreation center? The empty brick warehouses with painted sides advertising Coca-Cola and such? Or is he looking for a cold drink at the old Mug and Cone? The country club? Maybe he's heading downtown, which is thinning out like most American downtowns, but there is still a library, a town hall, banks, and the clothing store, a sports souvenir store complete with in-house pet pig, and a few thriving gift shops. There is even a Chinese take-out place and a full-service seafood restaurant. No socializing for Ardmore today, though. He takes the straightaway to Bluff Hall, where the other wealthy family lived in their Greek Revival mansion. Now it's a museum sitting high on its brick haunches, with its slim pillars and tall windows standing proudly out front. A small building sits off by itself in the yard. It looks like a smokehouse or a storybook cabin in which a whole family might huddle around a rough-hewn table for ham hocks and corn bread and turnip greens. Maybe it's a summer kitchen raised on brick stilts, placed that much closer to the river so the cook in her flour sack apron can feel a breeze lap up her skirt, small but welcome relief. Her ladle is deep in a cast iron pot. She is sweating and reaches for her water glass, wipes her hands and head with a rag. She opens the slatted door and faces the limestone bluffs. The riverboats bob between the white wedges of land. Steamboats and paddle wheels, rowers and swimmers are cradled in the current. She listens to the watery traffic, maybe sees a dog trotting busily toward the bank, thinks about her

family on the other side of town before she turns back to make a feast for a visiting diplomat. All history.

Ardmore takes his catch to the edge of the great white bluffs, a species of their own. There must be tales of people careening off the bluffs' stacked sides, unaware of the drop-off in this otherwise ambling landscape. The soft stones yield slowly over the years to the river, leeching their chalky sides—they are truly chalk; every child in town has written his or her name on the sidewalk with a chunk. The white mass looms over the river-goers while the willow trees weep over the sides. Ardmore trots to a grove of willows to bury his padded underwire bone and to die. What better place than at the lip of the mighty and submissive bluffs, on the property of a historic landmark? The woman regrets that he took with him her best bra, that he didn't have a taste of his favorite ice cream before going, and, of course, that he has gone at all.

The woman notices her dog is missing. She leaves her laundry luffing and calls him back. He is licking my shoes, so I give him a pat on his wide, flat head and shoo him home. She waves and shouts thanks. The screen door bangs behind them. She's probably going in for a nap or to call a friend about what to make for tomorrow's bridge club. I leave my fossilized soldier and my dreaming to buy toothpaste and a new notebook at the drugstore. Everyone in there checks me out to see just who I might be. Certainly not from around here, though I'm not sure exactly why they don't see the Demopolis in me anymore—these people must be the new generation. What betrays my out-of-state address? My sensible shoes? No lipstick? Maybe it is the way I speak in high school French to the cashier and ask for directions to New Orleans.

Confederate Jasmine

*M*iz Pinky Goodloe lives near the new hydroelectric plant in Weston. The plant is expected to fuel the first boon this area has seen since the riverboat days. Tourists and fishermen. As with so many of the towns I am attracted to, there's not much to Weston, not yet anyway. They have a tiny everything-store, a bait shop, a community center and three churches, and a handful of devoted citizens, Miz Pinky among them. There are many decrepit old homes and a few restored ones. It's slightly depressing, but I've come here because my great-great-great-grandfather founded this town.

Local history has it that in 1832 the land was connected to the Treaty of Dancing Rabbit Creek. A white man, who was married to a Choctaw Indian woman, came into 400 acres—how he did so is an uncomfortable mystery to me. Two parties wanted to buy the land from him; he decided whoever got the money to him by sundown was the new owner. That's where my horse racing, gambling, entrepreneurial ex-Yankee grandfather came in. He was determined to improve his lot down South since he'd frittered away his small fortune up north and was thrown in debtor's prison with nothing left but a table setting of silver. He had the ire of the county on his back since he had not completed the local highway they had paid him to build. When finally released, he moved his family—his wife and their three children—south to remake himself as a church leader, of all incarnations. He served time and then the Lord; I guess that's not such an uncommon evolution.

What we have of him is this town, his wildflower herbarium collected from the White Mountains of New Hampshire, verification of his enrollment at

CONFEDERATE OR YELLOW JASMINE

JASMINUM FRUTICANS

Princeton (or was that his brother?), church ledgers attesting to his regular attendance, town records of his real estate dealings, and photocopied excerpts from his granddaughter's diary about his temper, his love of nature, and his propensity for taking risks.

In 1832, Grandaddy raced on horseback to the finish line with a bundle of gold garnered from some new enterprise or lucky draw at a card table (must have been before he found religion), and claimed what became Weston. The Choctaws and the other Native Americans were forced onto the Trail of Tears while the town founders (Grandaddy had partners) busied themselves with importing new residents. These newcomers eventually prospered by growing wheat during the heyday of the river economy; the Tombigbee flowed by just down the steep limestone bluffs near their homes. Many of these people were from New England, so the early homes and the first church were exact replicas of New England buildings. My grandfather furnished the church's potbelly New Hampshire stoves and Revere bell. The slave gallery in the church is the only architectural detail to distinguish his change of locale.

Miz Pinky Goodloe is self-appointed historian and die-hard Confederate of Weston. She lives, ironically enough, on Yankee Street directly across from my grandfather's first house. I have called ahead to request a tour of the home, or what is left of it. Miz Pinky will oblige for as long as she can still walk and talk. I assure you she can still talk, though walking appears to cause her some pain. "When you get old, they start replacing real bones with plastic," she told me last visit.

I walk between the columns on her front porch, knock on the screen door, and yell for her over the growl of the vacuum cleaner.

"Just fixing up this mess a minute. Come on in. Come in."

Her house was built in pre–Civil War days. It heaves to and fro, the wide floors creak, paint and wallpaper are peeling. The house stays damp no matter what time of year. She seats me in the front parlor and offers instant coffee,

milk, Coca-Cola, whatever she's got so long as I don't go in her kitchen. She's got a brood of newly hatched chicks running all over hell and back in there. I say I don't mind because of course I want to see them.

"Well, all right, but don't you dare go in my bathroom. It's such an ungodly mess, it's a science experiment. You'll just have to hold it, I'm sorry to say."

The kitchen is a masterpiece of disarray. She scoops the fuzzy chicks two-to-a-hand and throws them back into their ineffectual cardboard cage. "Just don't look too close at the mess. The vines have broken in and I'm too busy to do much cleaning."

The vines have grown up so thickly around the outside of the house that tendrils have forced their way through the open window and hang over the kitchen sink. Her dishes are scattered, clean and dirty, on every countertop along with her bursting homegrown tomatoes and last year's Christmas decorations. Miz Pinky has her priorities straight; she keeps her kitchen together enough to serve her and goes on to other things. She fills our glasses with water and leads me back to the parlor.

"Now this house is uneven as a boat paddling upriver so watch your step, and it's full of ghosts, too. Mr. Meriweather comes to see me every day. He sits in that velvet-cushioned rocker over by the fireplace. I know 'cause the chair starts rocking soon after lunch and stops an hour or two later. I talk with him while I'm painting china plates or paying my bills, but he doesn't say much in return. He's just a lonely old man with a crush. On me if you can imagine!"

The parlor is full of chairs. Miz Pinky could open an antique chair shop with half the attraction being the story she'd tell of each ghostly occupant. "That's Miz Dowd's chair, she was the town's first librarian. She went to college in New Orleans and lived all over the world and came here to grow old and die. And that ladder back is Jimmy Reaves's who couldn't sit still a day of his life. And that cane rocker is Alvena Wallis's who used to have sex with herself on the playground at school, and that one . . ." Six chairs later, we cross the

street to the old family house, which is owned by someone who lives in North Dakota. It too is overcome with vines. Miz Pinky's son has mowed the lawn just this morning so the air is pungent and chewed grass sticks to our shoes. The porch bows under our feet as Miz Pinky points out the crude lock on the door. I untwist two rusty wires and pry the door open. At one time this house was a showpiece, but certainly no more.

"My hip's hurting me, Sugar. I'm going to sit right here on the front step while you show yourself around. Come get me when you're through. I tell you, it smells in there. Must be another dead owl somewhere. And watch out for loose floorboards."

The stench is suffocating. I hold my nose in the living room where the owl is lying amidst the old shutters and fallen plaster with a broken neck and a still-watery, slowly dehydrating eye. I turn away and go from room to room. Each is large and airy, with tall ceilings and generous light. No wonder; on both floors where there should be doors and windows open frames lead to the lush woods beyond. I find all the dangerous spots—where the floor is weakest, or the chimney an avalanche of bricks, the chandelier dangling precariously. Window frames and shutters are stockpiled in each room as if someone were opening a salvage yard. I climb the stairs and hold tentatively to the banister, which looks like a jaw full of broken teeth, it is missing so many rails. From the top of the spiral stairs I can see through the dark foyer to Miz Pinky out in the fresh air. She is calmly shooing bees and bugs while she waits for me, that young woman who wants to walk around a historic dump.

The bedrooms still have four-post wooden beds with tattered mattresses turned on their sides. Crusty button-up shoes and broken wire-framed eyeglasses are abandoned in the warped bureau. Books are pinned beneath the andirons in a fireplace. The back rooms are so caved in I avoid them altogether and go downstairs. What was once the kitchen or pantry now has an upstairs bedroom in its lap. The sun filters through the fallen floor, an after-the-fact

light well, and illuminates every bug and dirt clod, every lath and splinter of cypress. I jump out where the kitchen door would have been and land next to the well, covered now only by thin, rusty sheet metal.

I can hardly imagine anyone ever having lived here. I try to. I want to see my ancestors finely dressed, reading those ruined books, sitting by a fireplace and listening to their oldest daughter play the piano. However, my wish for them to have been wealthy and learned leads to the inevitable question: did they have slaves? They must have, considering the size of the house, my grandfather's prominence in the town, and the times, but I don't think they had a plantation. Until recently, when my father got interested in genealogy, my family had no knowledge of itself prior to the turn of the century. We knew we'd come from hardscrabble, honest laborers who did well enough for themselves. Now I don't know how to place the family historically. I don't recognize us. It's a curious mix, this pride in my family having been enterprising and successful, and this shame that they may have owned human beings and displaced Native Americans—who knows and how do I find out? Do I want to know? The truth may be disturbing or elusive, but one thing is certain: this house, in its fallen glory, makes a mockery of any sentimental notions I may have had about restoring it. Only millions of dollars and a serious case of genealogical daydreams could do the job.

Standing by the well, I am struck by the juxtaposition of this decayed, murky history and the bounty that flourishes around it. Wild berries ripen along the bluffs and bees gather around a profusion of small yellow flowers. As I return to Miz Pinky, the dead owl wafts back. She is leaning against a column and holding a sprig of the yellow flowers.

"What is this flower?" I pick some and smother my face in it to ward off the owl.

"This is Jasmine. Sweet Confederate Jasmine. Smells good, doesn't it? It's taking over my garden and I let it. It's been growing here since long before the

Civil War. You know, I still hang my Confederate flag. And I'll tell you one thing. I know if we'd hung on just a little longer, we could have won the war. We were just about to turn things around when the Union army swept through. We've got more Confederate soldiers buried here than any other town for miles and miles. We even have a Union cemetery and Confederate Jasmine grows there too. We forgive, but we don't forget. I'll hang my flag till the day I die. The South will never die, Sugar."

"Why are you still a Confederate, Miz Pinky?"

"Why? Lord have mercy. Because I was born here, because my ancestors were killed in the war just like yours. The South was steamrolled, Sugar. We've been the underdog forever. That war wasn't fair, and we've got to remind people of who we really are, good people who were used so the North could profit and smell good. Someone's got to keep the rebel spirit, and it may as well be me."

But not me.

The neutral Jasmine grows all over the carcass of my long-dead grandfather's house. At what point did he become a Southerner, I wonder. His New Hampshire kin fought his Alabama kin right up to these dilapidated steps. The granddaughter's diary said Yankee soldiers came to ransack the house but one of them recognized his family and left everyone alone, only turned the milk over. The granddaughter hated the Yankees, forgetting or not caring that she was almost one of them. At least she felt she belonged somewhere, which is more than I can say. My allegiances are split down the middle—north, south, or neither, depending on the sentiment of the moment. I like to think I would

kudzu

have been an abolitionist, or at least against the war. What if soldiers had come to my house deep down here in Dixie? What would I have been then, besides dead or destitute? I wonder what became of the people the granddaughter tells us had to steal grain from their old horse barn to survive during Reconstruction. I bristle when the Civil War comes up in conversation, which it eventually does; it's such a confusing issue. I wish sometimes our branch of the tree had stayed North. But then we wouldn't be us at all. I wish I weren't preoccupied with roots. In a strange way, I understand why Miz Pinky holds on, but not to what exactly: her sorrow, the pride of the downtrodden, a dream?

Miz Pinky leads the way back to her limping house, her last bastion of the Old South. She gives me a jar of pickled okra, some tomatoes, and a local history pamphlet. I leave her to take her nap and to find myself a bathroom. But first I read the introduction: "Those original Yankee ancestors (and their descendants, too) were mostly Southern as corn bread, turnip greens or the yellow Jasmine that perfumes the woods in spring." Maybe the author was right, but just what does *southern* mean?

Sweetwater Gin

I am sitting with my cousin David by a swimming pool overlooking the Gulf of Mexico. David is the eldest cousin of fourteen and I am the youngest. We both proudly claim our places in this wide span of offspring—one the witty archivist, the other a perpetual tag-along kid. Our friendship is all the more poignant because we are head and tail, first and last, neither old nor young. He is closer in age to my mother than to me and was as much her sibling as he was her nephew.

I like this link to my mother's childhood. When she and David are together, my mother's accent, watered down by years of living outside the Deep South, thickens and percolates. She is winsomely nostalgic and effusive as they match each other story for story, laugh for laugh. They even share the same high forehead—a mark of intelligence, they assure me since I, too, have it.

In my mother's absence, David and I still have plenty to talk about—family, of course, the South, marriage, music, odd characters we have known. He takes his roles as font of southern history, tour guide, elder, friend, and southerner quite seriously, though never so much that his laughter, loud enthusiastic exclamations, or poetry are far away. When he heard I was interested in the South, he sent me a sample of the infamous kudzu plant along with a poem he'd composed, which we have both since misplaced. But I remember the last and most telling line: "Hell, it'll grow up through your floor!"

At the pool by the Gulf, on a firm slab of concrete, we are so hot we are sticking to our plastic patio chairs and need to change our clothes even though we just put them on. It is six o'clock in the evening, and we are saturated. We

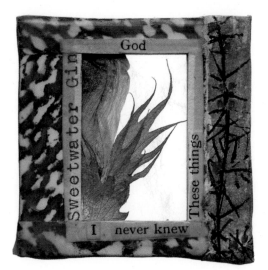

God
Sweetwater Gin
These things
I never knew

COTTON

GOSSYPIUM HERBACEUM

are having a cool drink before we go out for dinner. The Grand Towers, the pink stucco hotel where David is staying, lifts out of the beach like some kind of misguided elevator shaft. Somehow it has gotten separated from most of its skyscraper neighbors in Miami Beach, though a few of them have found their way here, too. At the moment, these particular towers are full of law enforcement officers from all over the South. They are attending a conference. I would never have guessed who these people are if it weren't for my cousin, an agent, or the lot full of patrol cars with various insignia on their doors, or the unmarked cars with powerful antennae and high beam lights. A few people even wear FBI T-shirts as they lounge around the pool. Could mistake them for a bunch of clean-cut tourists, if you were half asleep.

Every few moments David introduces me to another colleague. I've met agents from the Waco fiasco, Oklahoma City bombing, Ruby Ridge, and the Unabomber investigations; I am surrounded by reminders of the country's tragedies here by the sea, by the sea, by the beautiful sea. I am wondering how all these people decided to go into law enforcement. I could probably never pass government clearance, because of petitions I've signed in the past, or because I forgot to pay a bill on time or some such obscure default. My mind is wandering all over town when David calls out to the latest colleague, Curtis.

In the past I would have distanced myself from this group (blame a vague distrust of authority, a naive attraction to conspiracy theories, and a cheeky habit of making generalizations), but because I love my cousin I now look first for the person behind the job and try not to jump to conclusions. After all, I'd want these agents around if anything awful were to happen. Feeling open-minded and well feted by David, I greet Curtis. He is in his late twenties or early thirties, a lawyer for a branch of the government. He doesn't strike me as a lawyer. No suit—well, his swimsuit—no linguistic tricks, droning rhetoric, elliptical argumentative conversations (so much for my open mind). He is soft-spoken, gentle, and is even carrying the Shambhala pocket edition of *Zen*

Buddhism. His beach towel is draped over his shoulders and his rubber thongs snap on the patio as he comes over to our table. David tells me Curtis is an Alabama native from the same hip-pocket town where my great-grandparents lived (my father's side), between Sweetwater and Nanafalia. I've never met anyone who lived there, especially not anyone my age or of his professional ilk. With his warm, slow accent, Curtis asks me if I still have relatives living out by Sweetwater. *No, no. Not that I know of, but we have land. Lots of land.* His eyes light up and he jokes about needing somewhere to hunt. I am ready to give him access—as if I had the authority, as if the rights weren't already leased to someone, as if it weren't just forty acres—for this is the first time my roots near Nanafalia have meant something to someone else, short of providing exotic yet homespun images of the Deep South for friends of mine who have never been here.

I tell those friends about my great-grandparents' homestead. *Fish pond, cotton patch where the girls hoed, stalked the boll weevil, picked and chopped the cotton, did whatever else was required. Their father and brothers went hunting and fishing. Vegetable garden, smokehouse, henhouse, the wooden people-house. The chickens and dogs running under the house and the solitary treasures lost under there: a rotting shoe sole, a marble, a Coke bottle, a cement rooster lawn ornament. The wasps' nests hanging just above the porch swing like a miniature torpedo squad about to assault the family. How they had to hang the baby crib from the ceiling so rattlesnakes wouldn't crawl in where it was warm. Great-grandaddy casting his fly rod in the yard and hooking the knobby ridge of his ear. The tin of giant peppermint balls he kept near the couch and would drag out for the great-grandchildren. Boiled cabbage, hot peppers in vinegar, pond fish fried in cornmeal. Gathering warm eggs from the crumbling henhouse. The sweet musky decay of old timbers and hay bales. The path into the woods. Pine straw on the driveway.* These are the images I see while the lawyer, Curtis, talks.

He is half joking, half serious about the hunting. I tell him about the time

I was walking the property to check on the timber crop with my family (select cutting and replanting). We, including my somewhat frail though adventuresome grandmother, were entangled in the briars and picking our way toward the next puny sapling when I heard shots. They came closer and closer, accompanied by barking dogs. We stood in the ebbing late afternoon light like camouflaged creatures in our muted clothes—beige overcoat, ecru slacks, russet sweaters, and evergreen shirts bland as the gray wash of sky. My imagination went wild with scenes from the movie *Deliverance,* the source of the most enduring and haunting images of southerners as backwoods half-wit terrorists—what a task to undo the oft-made assumption that everyone or his cousin south of the Mason-Dixon Line could have starred in the film. As far as I was concerned, these people were stalking us for no good reason on our own land. Or just blindly shooting at whatever stirred in the woods. To die in a briar patch, mistaken for a raccoon or a nervous deer, was not my idea of a good way to go. Leaving my family to carefully free themselves from the thorny branches, woven one into the other like Girl Scouts pot holders, I ripped through till I reached the dirt logging road and sprinted to the car. I've never been so glad to see my grandmother's Pontiac with its heavy metal doors.

So by now I am sure I've given Curtis a sterling first impression. Polite as ever, he still wants to know if we are the Lewises from Sweetwater who still *live* there. And I say maybe, because my father was born in Sweetwater. Maybe there is someone left I don't know about.

The Lewises own the gin company.

No, I don't think so.

No, the Lewises own the gin. Are you sure that's not your family?

No, no. I doubt it's the same Lewises because they were teetotalers. They would never have owned a gin company.

By now there are several agents and lawyers at our table, having sensed something good going on our way. They are laughing great head-thrown-back,

deep-from-the-diaphragm laughs. What a fool. David pipes in.

Gin. You remember Eli Whitney. He invented the cotton gin just as slavery was on the wane along with the cotton industry and lo, the production of cotton took off. King Cotton took his throne. A northern invention, may I remind you. C-O-T-T-O-N. Cotton gin.

I am humiliated. I knew it was a cotton gin in Sweetwater, knew it was that rickety sheet metal warehouse with beat-up chutes and conveyer belts. I even took a photo of that building and framed it one Christmas as a present for my father.

If it were a gin company as in liquor, we wouldn't be sitting here; you'd be taking us all out to eat. What would they be doing with a gin plant in Sweetwater, Alabama, Lawd have mercy? David loves this one. I can already hear his perfectly timed, perhaps slightly exaggerated version being passed on to my mother, his mother, his good-humored wife, all the cousins stretched between us and whoever else would appreciate my dizzy lapse. Curtis has raised his eyebrows to new heights, no longer the southern charmer-Zen Buddhist. Now's he's a just-plain-stunned human being. A lawyer whose questioning garnered an unexpected answer.

We all agree that Sweetwater would have been a great name for gin, had the gin not been a piece of machinery but the elixir I now crave. *Sweetwater Gin*, distilled from juniper berries, not cotton. All the more fitting since many of the agents standing around us, David included, started out hunting illegal stills. I tell Curtis it was nice to meet him and that I never want to see him again. *Funny, a lot of women say that when they first meet me* he says as he backs away in mock dismay. He goes up to change for his dinner date with a woman he's just met. I congratulate myself, at least, for providing these venerable, friendly agents of law and order with a story for the repertory: Dumb Things Yankees Say When They Come Down South.

Swimming

I wade out into the tepid Gulf, stirring up the fine sand to warn stingrays
of my arrival. I see a small one, much smaller than what I've been look-
ing for, which is a giant Caribbean ray featured in *National Geographic*.
A meaty elephant ear with a kite's tail swimming behind it. This one is about
a size-four boy's shoe, a ripple of skin, pale as the sugar white sand, skating
silently just above the floor. I am also looking for jellyfish. They can be noto-
riously bad this time of year, but I don't see any yet. Tourist brochures tell you
what to do if you are stung by either creature. The litany of instructions criss-
crosses in my head as I prepare to dive under: is it meat tenderizer and vinegar
for the sting ray, hot water and a doctor for the man-o'-war or the other way
around? I notice the families down the way swimming with abandon, so I dive
in and bodysurf like I used to.

Even underwater I can feel the scorching sun. The temperature, my buoy-
ancy, the salty sting of the water conjures an almost tactile memory of cling-
ing to my father's cool, freckled back as we rode the surf. My sister and I
screamed with happiness, swallowing water until we were bloated or coughing
yet not stopping unless my mother waved us in with a sandwich or her sun-
block—a large metal tube with a thick stream of orange goo that smelled like
old cheese, tar, and Play-Doh. She slathered it onto our pale, pale skin despite
our protests. I thank her now for her foresight and slather on my own brand as
soon as I get out of the water. I am instantly sweaty. I try to take a romantic
walk by myself on the beach, but it is midday and my skin is burning up. I return
to my simple, cozy room at a bed-and-breakfast and take a cold outdoor shower

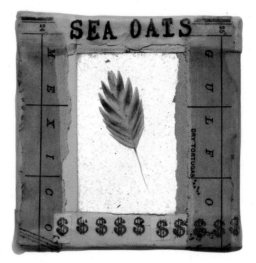

SEA OATS

UNIOLA PANICULATA

in a wooden stall where the owner has whimsically painted *The more sophisti-cated one becomes, the more one appreciates the primitive.* I fall asleep in a ham-mock contemplating this aphorism and looking forward to my next shower.

We used to come for a week's vacation and rent an efficiency in one of the few existing apartment complexes. Those that did exist were just two stories. We were right on the water, a fact that never ceased to amaze me. *You mean we open the door and we are here? No car, no toll, no parking lot.* My parents walked the beach at dawn and dusk. Sometimes before they left, my mother would wake us, gasping with excitement and pointing out the picture window *Come look, come look girls, quick. The porpoises. They're swimming right in front of us!* Their smooth bodies with blunt snouts plunged into the water, leapt up again in perfect unison, the original synchronized swimmers with no need for train-ing or Olympic medals. The morning light seemed to float on the water where no one else swam yet. The Gulf appeared to belong just to itself and was more peaceful for it.

This is when my mother liked to go crabbing. She'd tie a hunk of fish to the end of a rope which she dropped over a wooden bridge into the brackish water. She kept a net or basket by her side to scoop underneath her catch. Sometimes we'd go with her so we could witness the exciting fracas of claws as she lifted the crabs and dumped them into the bucket, but this moment was a long time coming, and we were usually too impatient. We were drawn instead to the open water where we'd stay until dinner, which was either a feast pre-pared in our apartment or at the local fried food palace: fried fish, crab, shrimp, hush puppies, slaw, ice cream, watermelon, pie. We always loved to eat. Eating and swimming. That was enough.

One summer we were caught in a storm. The wind was wild-eyed, the Gulf swollen and turbulent. All those hours of delight in the sun were eclipsed sud-denly by the eery sky. I parted the nylon drapes and stood in their scratchy folds to keep watch of the Gulf. The light was strangely bright on the horizon before

the clouds moved in. The window, slick with rain, now seemed dangerous, a sheet of plate glass waiting to be smashed rather than dreamily gazed through. As I watched, my air mattress down on the beach buckled in the middle and was bandied out to sea by the wind. Its lemon yellow, built-in pillow surfed the white caps; black swells took the mattress out, out, out to that crisp line where the sky met the water, two brooding slate planes fusing. I imagined the raft would slide between them at the last moment and land wounded in South America someday.

Lightning struck, followed by deep cracking thunder. The claps sent tremors through the thin walls of our apartment with its matching double beds and chrome kitchenette. We seemed to be living inside a diorama, just a shoe box with a worried little shrunken family huddled there listening to the static of the radio. My stomach ached knowing that my beach-frolicking, loving parents could do nothing about the raft, could not keep the walls up through the night, could not hold the windows still. Nor could they stop the lightning from catching hold of the antenna or the TV, from honing in on the fixtures in the bathroom or the shiny table legs, or igniting the air, even. The thunder would surely split us all in two.

sugar white sand

If only for the sake of dramatic effect, I wish that I could say there was a hurricane. That the windows shattered in our sleep, though we hardly slept. That the water pipes burst and the roof blew off. That the evacuation crews ordered us out with bullhorns, that my parents saved our wee lives by bundling us in the Volkswagen Bug and speeding along the causeway to Mobile or points farther north. But that is someone else's unfortunate, gripping story. No death or destruction of property here, just erosion of the childhood belief that nothing would ever harm us.

It is with these memories that I swim now. The threat of another storm has yet to come; only a week after I leave, a hurricane will blow through, barely missing this same beach while tearing up miles of real estate and killing several people. For me it is a tranquil though blistering summer, the heat so fierce you must surrender to it, drink iced tea, find shade, air-conditioning, take a nap. I go out at dusk for a walk on the beach. I look at oil rigs now, not just porpoises. Look at hotels and condominiums, golf resorts springing up in perfectly synchronized zeal. More rooms, more tourists, more business. Eating and swimming are not enough anymore, apparently. But still the crabbers and fishermen optimistically drop their lines and wait. Children gleefully swim far longer than any adult can bear. The sand is still so soft. No jellyfish nor camouflaged, barbed tails underfoot today and the water is very, very calm. It's good to be here again, older, and oh so sophisticated. Sound judgement and pure good luck keep me safe now as one memory floats languidly into another.

Jack Pot

*S*ea oats used to grow where this casino stands. Lots of them. Slender grasses waving three feet tall. The tallest grasses in the dunes. Those that are left are bending toward the water today, rounding their thin spines with the slightest hint of wind. Signs everywhere read *Save dunes from erosion. Do not pick the sea oats or any other grasses.*

I didn't pick the grasses. I swear. Someone else broke a stem off as he or she climbed onto the boardwalk with an errant beach chair or picnic basket. I now hold this beheaded wand of oats. It looks like matted hair, a shy person's wrung hands, or a dried up fan. The golden head is so similar to unrolled Quaker Oats, but they are different plants, oats and sea oats. Must remember to ask a botanist or a park ranger about that.

The low, gentle dunes undulate between houses. There once were long stretches of beach on the Gulf Coast, with few houses, simple wooden houses on stilts, not cement towers or townhouses or gambling palaces shaped like pirate ships or pagodas or showboats. There are enough houses already, and the casinos, while good for the local economy, are growing out of control. There are so many, they can't possibly all thrive. This sprawling, faux grandeur leaves me sad. Is there a land trust to preserve a wedge of this coast? One parcel that is not a sitting duck for the next enterprising developer? But even as I silently bemoan the changes to the coast, I also feel giddy anticipation about entering the largest casino, the one with a pot of gold glittering on the roof.

🍒 🍒 🍒

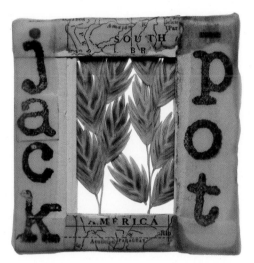

An electric shuttle bus takes me from the crowded parking lot up the circular drive to the entrance where we guests are greeted by red carpets, revolving doors, and a huge chandelier tinkling in the atrium foyer. I walk around with the other bedazzled consumers: the hungry, the voyeuristic, the desperate, the lucky, the bored, the what have you. I quickly notice that this is the first place in all my travels where every race, creed, class, and sex gather. I love it. Blacks, whites, Mexicans, Vietnamese, blue collar, white collar, old, young, the well-dressed, and the slovenly mingle like nowhere else. Curiosity and money are the mortar here; people are rubberneckers by nature and dollars are dollars no matter whose hands they pass through. Same for the nickels, dimes, and quarters. I decide to stick to small change, avoiding the room with high-stakes games—blackjack, poker, roulette, and others whose names I've never heard. I imagine opulent rooms with closed doors where the really big money is passed around. I take the escalator to where the no-mind slot machines await.

It is Labor Day weekend and throngs of people have descended on the slots. The hardcore zombie sorts have parked themselves for the day, while their roving counterparts stake out and queue up at the machines due for a spillover. I'd have to stand here for hours to play; it's satisfying enough just to watch the spectacle. I drift through a hypnotic sea of whistles, bells and horns, ratcheting handles, and spinning digital battens. Occasionally coins shoot out of a machine into the lucky winner's paper bucket, accompanied by every noise-maker in the joint. Not even the bathroom is quiet.

Saccharine remakes of popular songs blare as I enter the ladies' lounge. It's the red velvet world of a showboat or a bordello, I can't tell which. Cheap chandeliers hang over settees stationed in the middle of the room. The heat generated from the bulbs cooks large glass bowls of potpourri. The room reeks of pure artificial rose gas. A woman with a mile-high hairdo and a broken foot goes on and on in a loud voice about how fancy and classy this place is: *Even the bathrooms are just beautiful.* Beautiful. Oh please. I enter a stall with

"Nanette" (name and portrait) painted on the door. She is rouged to a nuclear glow. Her bustier is about to burst and liberate her cartoon-sized, honeydew breasts. Someone has done Nanette wrong with this painting, not just because she now adorns a bathroom stall; she is a has-been on the Great Riverboat circuit. Someone who still dresses like a twenty year old when it would behoove her to remove the showgirl skirt, cover a little more leg. I wash my hands and flee, getting hand cream and breath mints from the attendant on my way out. A nice perk, actually.

<p align="center">🍒 🍒 🍒</p>

I stand in line at the casino cafe for a lunch which promises to be a sky's-the-limit smorgasbord. We all dutifully wait, all this waiting, behind a red velvet cord just like at a theater. I slowly make it through the buffet and am about to sit down with a gluttonous, multicultural plate of soba noodles and mashed potatoes, cranberry sauce and stir-fry, curried vegetables and gumbo and jambalaya with apple pie and sopapillas for dessert when I notice an odd man. He is as tall and spindly as a giraffe, his neck extended as if on alert for what nuisance is bound to confound him next: a ripple in the rug, a child's toy, a dead branch, that pot of gold. The pot of gold would hardly bother him, of course. He is in the casino and he is carrying a veritable carpetbag, probably full of money. The bag is made of heavy floral fabric with a thick zipper securely cinched between the leather handles—do they actually still make carpetbags? He wears a flimsy royal blue windbreaker and Hush Puppies the color of cookie dough.

He takes a seat at the first available table with his rather ordinary wife and grown daughter. The women are wearing matching cotton pantsuits, their hair is well coiffed, their nails shining, their posture stooped like smaller giraffes feeding on the low-growing plants. As soon as they sit down, he grumbles and fusses until the women dutifully follow him to a table off in the corner.

I'll call him Jack Pot, I decide as I watch them move away. He could be a shrimper or a bank executive, own a broken farm or a fleet of oil wells. No way of telling really. Jack Pot cleaves his large, leaden feet apart with the bag, setting it down as he takes his new seat. He painstakingly unwraps the complimentary Saltines and eats them one mousey bite at a time.

It is amusing enough to think he is hauling his winnings or his investment risks around the dining room, but when he catches a chill, Jack Pot really becomes someone to talk about. The giraffes go through the buffet line, with the bag, and return to their seats. The air-conditioning must be getting to Jack for he unfurls his napkin as if to place it in his lap, but instead sets it on his head. He doesn't smile about his hat, nor do the mother-daughter team. They just continue to eat sparingly from their plates and watch the crowd scurry for food like frenzied red ants. The cafe host, who has been nothing more than an overdressed signpost till now, is startled into action and offers to get Jack a real hat. I look up a few minutes later and see that Jack Pot is wearing a cook's beanie; a cross between a sailor's hat and a nurse's cap. The sides are cardboard, the crown a ventilated, stiffened gauze. Jack Pot's crown is creased down the middle and will fold just so to fit in his back pocket if need be. This jauntily cocked, cheap thing could hardly be a source of warmth, but it makes the other diners and the man-

agement feel better. *Don't mind Jack, the crazy man with the sack full of money and the hat. He's one of the fantasy crew members now.* The daughter and the wife are as impassive as ever. Obviously this behavior is nothing new.

What happened to Jack? He was probably a nice-guy, barefoot surf caster way back when the sea oats and the dunes flourished. He didn't care so much about what he caught as how soft the water was on his ankles, or how delighted his daughter was as she dug holes in the sand or begged him to swim with her. His wife sat under a beach umbrella and read romances. They rented a cabin every summer. Those were the best days of their lives. Did he always fuss about every little thing—that there was sand between his toes, that the barbecue tongs weren't put back in the right outlined shape on the Peg-Board, that the sheets didn't have hospital corners and the oatmeal wasn't wet enough? Was he always humorless, dry as toast, strange? Or maybe he was a gambler before the casinos ever came. A nightly poker game on the screened porch, beer, Vegas whenever he got a chance. Or maybe the casinos, rising up out of the ocean like sunken treasure, enticed him. *Come hither, crane your agile neck way up here. Just one more inch and you will taste the perfect morsel.* Is he a casualty of this world of excess or a founding father, or something else altogether?

Overfed and overstimulated, I take one last tour of the casino. I imagine the casinos will soon replicate sea oats in silk for their decorations. No more riverboats or bordellos or pirate ships, but a real beach experience. With this new theme, they will issue everyone a bathing suit, a beach cover-up, and thongs before they enter the game rooms. The bathrooms will be changing huts with thatched roofs, sand on the floors, sunblock and iced tea on the bathroom counters. The attendants will be eager to fan you, spritz you with mineral water while you play blackjack in your trunks or that slimming black one-piece you just picked up in the adjacent gift mall. *Gulf Breeze,* the casino will be called. *Jack Pot's Gulf Breeze.* Where everyone is welcome no matter how shallow their pockets or how off-kilter their head. At least this way, none of us

gambling, gawking fools will ever forget that we are actually at the beach where the sea oats hitch their roots to the dunes for dear life, just mere tenants now.

I would go to *Gulf Breeze,* play the slots if I could get to them. A harmless five-dollar lark, one coin at a time, recouping a few dollars at best. But still, there'd be the chance, always the chance that the numbers or the fruits would pass through the same orbit, line up like neat little ships of gold at dock, and cough up their bounty. Maybe eventually I would need to carry a money bag like Jack Pot and travel far and wide with my crown, forget about yesteryear— some exaggerated, sentimental pining for what must change, anyway.

Whatever Jack Pot's story, he is partly why I come here and he is why I leave. He epitomizes something about the casino culture—the unexpected is so exciting, the yen to win so disturbingly one-pointed, the company so overwhelming. I return to my plain, rented beach cabin where I leave the windows open even in summer, no matter how hot I am, no matter how much I smolder, sweat, stick to the furniture. I want to know where I am. In the wide arc of the Gulf, tucked between dunes.

No-See-Ums

No-see-ums are attacking me. Actually, I see most of um. They are flies, pitch black ones and their yellow-and-black-striped kin. The park ranger I am standing next to says they have teeth of stainless steel. I say more like new razor blades. We are at the trailhead studying a map because I'm planning to take a hike in the wildlife refuge. The ranger tells me not to bother.

Go to the town beach. They spray there and it's great because the bugs don't bug you anymore. We had a group of naturalists out on the Pine Trail four miles in toward the lagoon. They were fully doped, wearing long pants, and even they were suffering. Bitten to death. Eaten alive. Don't go on a walk.

Spraying! I forgot they do that. A truck, loaded with poison, bombs the beach while everyone sleeps. Sounds like a street cleaner if you don't know better. For once, though, a DDT shower doesn't sound so appalling.

Idea: Kill a fly, with its banded tail end similar to a bee's but more angular, and mount it in lieu of the plants I would see if I were able to walk to that lagoon instead of running for cover to my air-conditioned rental car.

The plants are the real no-see-ums on this expedition. They have such pleasing names, as listed on the handy trail guide:

Pignut Hickory	Coral Bean
Climbing Butterfly Pea	Palmetto

Beautyberry/French Mulberry	Yaupon
Deer Tongue	Dog Fennel
Gopher Apple	Reindeer Moss
Sand Oak	Choctawhatchee Sand Pine
Fetterbush	Beggartick
Duck Potato	Buttonbush
Blating Bladderwort	Bitter Gallberry
Swamp Holly	Rattlebox
Saw Grass	Hairy Wicky

I sulk in the car and chide myself for coming all this way yet not getting outside enough. I want to be woman in nature rather than woman in car and hotel room, woman on plane, bus, van, and train. Weary of going to stores, museums, restaurants, and people's yards, I crave open space where I can smell everything, lie still, and look. The point of my travels, after all, is to roam the landscape. The ranger, who has gone back into her air-conditioned, modular office, is surely exaggerating. I defiantly don my protective jacket and walk into the park.

Live oaks and their sidekick, Spanish moss, form an archway at the trailhead. No flies so far, nor alligators, pythons, rabid raccoons, or surly mongooses. A few feet into the woods, the cicadas boot up with their bewitching buzz. The birds join in and I forget about the bugs for a moment as this dense, invisible Pied Piper orchestra leads me into the refuge. This place reminds me of a display of subtropical flora and fauna at the American Museum of Natural History in New York, and I feel as though I am here just before closing, cramming in as many sights as possible before they shoo me out or, in this case, before I'm forced out by the ubiquitous fly or other predators. Palmettos announce themselves from the forest floor like *Wizard of Oz* characters waving their pointy palm leaves just before they jump up and dance. A trail is an

unusual sight around here. I half expect to see Exhibit A, B, C signs, Nature Right This Way, but this is an actual foray into the wild landscape. Flowers I've never seen before open their fiery orange throats, purple beautyberries primp and blush in the hot sun. The sandy path twists and turns to points unknown. I step tentatively into the teeming forest toward what I imagine to be an undisturbed beach. With each movement closer to this postcard vision, I become distinctly aware that no one else is around. Woman in nature becomes woman alone in the woods in an unfamiliar town. I am so hot my neck is dripping, perspiration puddles behind my knees, my muscles have gone lax. If I had to run, I don't know if I could. Ears alert as a terrier's, eyes too wide, I am determined to go on, but my paranoia starts getting the best of me.

A daily browse through a newspaper should be fuel enough for me to avoid sojourns like this one, but now it's the chilling testimonials of women I know that resound from each bend in the trail. *Cheryl Davies was running through the woods and that man threw her to the ground, tied a sweaty T-shirt over her face, and raped her. Cathy Ramirez was walking on the beach and her ex-boyfriend jumped out of the tall grasses and stabbed her in the throat. Evelyn Ross's sister and her boyfriend were hiking on Mount Tamalpais and were murdered by the Trailside Killer.* I hear my own news story being read over a bowl of cereal: *Woman found bound and stabbed beneath fetterbush. Crushed deer tongue, dog fennel, and bitter gallberry at her feet indicate a struggle. Cause of death unknown* (or too horrific to describe). *Reward offered for evidence leading to conviction of . . .* what lurks OUT THERE. I am trying to swat these images away—and yes, the flies have returned, too—when I come upon a pair of women's Jockey underwear, torn to shreds and hanging on a bush. Maybe she, too, was hot. Maybe she was just tired of this particular pair. The elastic *is* sagging. Maybe she had a passionate, illicit rendezvous with Hairy Wicky and lost her head. But I don't care to wonder. That's it.

I return to the parking lot angry that my attempts to commune with nature have been thwarted by threat of aggressive insects, unlucky charms, and pure fear. Wondering what's worse, fear of nature or fear of my fellow humans, I try to comfort myself by sitting under the live oaks with their hugely dramatic appendages, the hitchhiking moss, swinging low. Choose your story about the South and Spanish moss will be there, silvery and green, with the slightly iridescent, spooky sheen of old fish scales. There is so much of it I scoop some off the ground to passel away in a Baggie as a consolation prize, sort of like receiving a party favor at the front door because the birthday girl woke up with chicken pox that morning and has to cancel. But before sealing my prize in the bag, I play with it. (Bad, bad tourist. I am not supposed to take anything. But I figure it doesn't count if it comes from the parking lot.) Each handful is a nest of soft-tipped curves with oak leaves enmeshed in the miniature, antlerlike splays of greenery. When I squash the spongy nest, it springs back. I read somewhere that people used to stuff furniture with this moss, which is an epiphyte. It lives off the air, not off its host like a parasite or leech. I sit in the parking lot, shrouded by the Spanish moss and its attendant myths (the Southern belle is too delicate to venture into the woods alone), imagining what else I'm missing in the splendid living museum. A dip in the lagoon (there are probably alligators or giant snapping turtles). A shady cove (long-legged water birds and sand crabs). The question irks me so, I give up entirely on the refuge—an oxymoron at this point—and go to the bugless beach. Only later, with my hand lolling in the sand, do I realize I never thought to look for the woman who may have belonged to the Jockeys. I decide they've been around a long time and are mere litter at this point. But has anyone ever investigated the gray panties in the woods?

Lively Oaks

I met an extraordinary woman this summer on the Gulf Coast (seems I always meet at least one unusual person when I go south—that's one of the reasons I go). We were staying in the same bed-and-breakfast; I was paying and she was family.

My plan was to linger a few days in a small town renowned for its architecture and art. I was also going to take a boat out to a barrier island where supposedly the flora and fauna have full reign. A long walk with a notebook, a picnic lunch, and a bathing suit—what could be better? But this excursion was not to be; no leisurely walks through town, no undisturbed beaches, no Dr. Seuss–like longleaf pine trees, no king birds or Sargassum crabs. When I drove up to the bed-and-breakfast, the owners greeted me with wide open faces and a message.

Athletic, lanky Evelyn and small, springy Candace stepped forthrightly across the yard in matching tropical print shirts and offered their hands. Each of them had a firm handshake, something I admire in a woman. No fish wrists here. Evelyn, with steady brown eyes, delivered the message while Candace stood quietly at her side: "Come home tomorrow." Though we didn't talk about the details (an in-law's terminal cancer relapse), they recognized trouble. What a nice pair, I thought, and wondered if they were a couple. Whatever my hosts' story, I liked their style—empathetic without prying. They led me to the office and kindly suggested I take a ride on one of their three-speed, fat-tired bikes before I had to head north in the morning.

I met the woman in the office. She was lounging on the daybed with a

LIVE OAK

QUERCUS VIRGINIANA

book, dressed in a T-shirt, no-funny-business Carter's cotton underpants, and nothing else. She smiled and waved me in, though she looked a bit perplexed by my presence.

Who is she? she whispered gruffly to Evelyn.

A guest, Colette.

Oh. Like me.

No one is like you, Colette.

That's the truth. One glance and I knew Colette did whatever she wanted with her life. She was in her seventies, had the tawny, weathered skin of a sun lover, painted red toenails, and tough heels. Her gray-streaked hair was still wet and salty from swimming in the ocean and was matted to her square head. No makeup, except for smudged mascara. A few large, gemless rings adorned her thick fingers. She was short, plump, strong. I had an impulse to hug her or wrestle with her. Evelyn and Candace introduced Colette as their adopted grandmother. Colette asked if I was visiting on business. I told her I was writing this book. Fiction, I said, so I wouldn't be expected to write about them (or anyone else) as they see themselves. They all responded at once. *Oh, that's great. Good for you. Be sure to let us know when it comes out.* I will. I will. Candace showed me to the bike shed and my room.

My simple cottage sat squarely off to itself beneath a huge live oak tree which, in concert with several younger trees, shaded the whole yard. Silver, tousled wigs of Spanish moss hung from the limbs. These limbs, their elbows akimbo, begged for someone to drape lazily over them—a lion or a tourist would do. A hammock was strung between the trees and slumped invitingly off by itself. The lowest branches of the old tree sagged so heavily they would have touched the ground had Candace and Evelyn not made crutches out of forked stainless steel poles. Small, coarse fernlike growths, another epiphyte, stood straight up from the mossy bark. They were the Lilliputians of the live oak family, a thriving colony of air plants roosting in these generous trees.

There was room for everyone here at Lively Oaks—this is what Colette later told me she called the bed-and-breakfast whenever she answered the phone. She could never remember the real name—some bland reference to an oak tree: Oak Grove or Oak Plantation. Her version was more apt, anyway, as she herself proved.

I went for a short bike ride around town. Thank God the roads were mostly flat since it was as hot as Hades and there was all that metal to move and only the three gears. I pedaled through the wooded residential neighborhood of mostly one-story ranch houses and wooden Creole and Queen Anne cottages. The famous architecture of Louis Sullivan and Frank Lloyd Wright must have been hidden away in the lush trees—I'd have to see those houses on another visit. People waved to me from their cars or the sidewalk, even though they'd never seen me before. In a matter of moments, I was in the heart of town. The streets were laid out in a grid, not a tall building in sight. It was a slow-paced, old-fashioned downtown, much to be prized in this era of Walmarts and shopping malls. I zipped past the pharmacy, a bakery, a local bank, several art galleries, a barber shop, and even a thriving health food store—an equally rare sight—and headed for the water. Gentle rises and long flat stretches on the beach road gave me plenty of space to daydream. I knew I'd be spending a lot of time at the hospital soon; it probably wouldn't be long before my father-in-law died and after quite a struggle to live. I stopped on a bridge that straddled the wetlands, and I looked longingly across the sound at the perfect silhouettes of the stilt-legged pine trees on that island. Oh, to flee to that wild haven. A fishing trawler puttered toward the harbor; the afternoon sun lay on the still water, thick as mercury.

It was getting dark; harder to see, harder yet for cars to see me. I pumped my two-wheeled companion toward the bed-and-breakfast, up, up a small hill through a tunnel of oak trees: branches dipped helter-skelter to the ground while others scribbled toward the sky, the sidewalks buckled from the far reach of the

EPIPHYTIC FERN

POLYPODIUM POLYPODIOIDES

roots. I coasted downhill, making the humid air move and reveling in the shade.

On the way back to my cottage I passed the kitchen where Evelyn, Candace, and Colette were just finishing their special taco dinner prepared in honor of Grandma Colette. They waved me in. *It's that writer woman who seems friendly and sad. Let's ask her to sit with us.* As soon as people find out I am writing a book, they want to share their unwritten tales with me as if they were family heirlooms.

Candace and Evelyn pleaded in unison. *Tell her. Tell her how you eat mangoes. Tell her how you eat mangoes, Colette.*

Seated on her chair cross-legged, her arms loose at her sides, her laughter easy and uproarious, Colette held court. *I get a big bucket of ripe mangoes, strip naked, and sit on my stool in my bathtub and eat one after the other. When I've had enough, I turn the shower on. No more sticky. That's it.*

I imagine this woman peeling back the rubbery skin with an excellent paring knife, until the sweet orange fruit slips from beneath her firm grip and into the bright fluorescent light. She drags her teeth over the oval pits to get all the meat. Peels and pits surround her naked body. In all her heft and strength, she is the portrait of the Venus of Willendorf—a squat, full-bosomed figurine of an ancient fertility goddess. The water from her shower is a vivid punch as it funnels down the drain. Afterward, she certainly does not scrub the tub to a Good Housekeeping white.

Candace and Evelyn glanced knowingly at one another, smiled like girls at a slumber party. Evelyn nodded to Candace who prodded Colette in the ribs. *Tell her how you eat crabs, Colette. Tell her.*

Alright, alright. No poking necessary. You know I love the sound of my own voice. She turned and fixed her bemused eyes on me, paused a beat and began.

I eat those in the center of my queen-sized bed, which I do not share with my husband of forty-five years. I think he's a moose and what he thinks I am, I don't know—we keep our own rooms for self-preservation. Anyway, I get myself a dozen

crabs, not soft shell, please. The real thing. Grown-up, mature, meaty crabs. A few long neck beers, a beer flat, the Sunday paper, some lemons, and nutcrackers. I cover the mattress with the paper. Naked—I do just about everything naked—I sit in the paper nest and eat.

I could hear, smell, see that bedroom. The cracking claws, and the sucking, the slurping. Shells rattling together. The newspaper crinkling as she shifts her weight. The noise dies down as she gets deeper into the dozen and the paper becomes saturated. Her husband, the Mystery Moose, has been known to sneak in to photograph her at work, though she can't understand why. I imagined them going to the grocery store as usual one morning. She has a yearning, turns to her husband and tells him it's time for a crab dinner. He chuckles and rolls his eyes as she winks slyly at him. *Come on, Bullwinkle. Give me a hand loading this cart.* He throws in a roll of film as they're checking out. What I would give for one of those photographs.

The stories could have gone on and on, I'm sure. I was very hungry, though, despite or because of these gustatory tales, and needed to get to a restaurant before it closed. In the process of thanking them for inviting me in, it came out that I didn't want to go home at all and that I am terribly afraid of flying. Colette reached into her travel bag and gave me a small clay figurine . . . the Venus of Willendorf, of course . . . which she had made. *Safe trip home,* she beamed mischievously.

I ate crab for dinner. I went to the nicest restaurant in town and read the paper between courses to ease the awkwardness of eating alone. The horoscope coincided with dessert. Such pedestrian irony. Cancer is represented by the crab in astrology. Even if you don't put much stock in the stars, the symbol is what counts. *Tell her how you eat crabs, Colette!* Tell me how you crack cancer, while you are at it, I thought to myself. The crab is so misleading a mascot for cancer. There are no protective shells, no claws to fight with; there is no sideways shuffle back out to the warm Gulf Stream and no neat constellation of stars to tuck

under your skin for easy explanation, to tell you what to do when you get really sick. I finished a heaping mound of bread pudding and returned to Lively Oaks, where these friendly strangers had taken care of me, given me comic relief and solace, hosted me in their jewel of a town. At home, strength would have to come from somewhere else. I put the miniature Colette in my carry-on bag and went to bed early. I watched the oaks like craggy-armed nurses cast car-lit shadows on my wall till, at last, I fell asleep.

Kudzu

One summer vacation when I was a teenager, I went south alone. Mrs. Rice, an old family friend, took it upon herself to entertain me. One day, she showed up at my grandparents' house in her usual straw hat with flowers and a nice dress, straight from her weekly bridge game.

"I figured since you are a Yankee now you wouldn't be able to take the heat outside. Thought you'd probably shut yourself up in the house. You need to get out." She invited me for a country drive in her long blue Chrysler to cool off and get a change of scenery. I was a moody teenager who preferred listening to talking, which was good because Mrs. Rice was my opposite.

"Yes, ma'am. I'll go with you."

The air-conditioning was on, but still we stuck to the plastic seat covers and tried to see through the sweating windows. Mrs. Rice pointed out familiar sites: the freezing cold schoolhouse where she once taught; the catfish farm owned by the paralyzed man; the dingy house where the man who sells peaches from the back of his truck lives in sin; the place where the tornado touched down and whirled whole families away. Mrs. Rice tended to dwell on the grimmer things in life—but with a smile.

"This air-conditioning sure does the trick, doesn't it, Sugar? I was just about to fall out in my house. Russell and I used to go for Sunday drives on Monday, Tuesday, Friday, whenever we needed to stir the air. I still didn't have air-conditioning in my house then. Russell thought cross breezes, high ceilings, and rotary table fans ought to do fine. He was old-fashioned, didn't like things to change too much. He wouldn't buy a TV until the moon landing." I don't

KUDZU VINE

PUERARIA LOBATA

remember Mr. Rice, though I've been told we met.

"I sure do miss that man." Her eyes teared up. I got embarrassed and looked out the window. Kudzu was creeping over every branch and down every embankment. It seemed too beautiful to be an annoyance, its large, bright green, three-lobed, lopsided leaves climbing and cascading everywhere. It grew over anything in its path and insatiably took whatever it encountered as its own. From one set of roots sprang whole rows of giant, sensuous plant sculptures, like cartoon monsters or oversized puppets. You couldn't even tell what was underneath the mass of vines: a fallen chimney could be a fallen tree, a field of hay bales, or a bevy of dead cars. If not dead cars, then what? Dead bodies, lost towns, children and pets, thick snakes sliding around. Lots of them. I really didn't want to get out for a walk, and I knew Mrs. Rice wouldn't have the slightest interest either.

"That's foot a night you're looking at. Kudzu. It's the South's blunder crop. It may as well be an animal the way it eats everything up. My husband is partly to blame for it. He worked as a county agent for the Farm Bureau, see, in the 1930s. He was a young man then and full of steam. He'd grown up on a farm in Jefferson County and loved that land as much, maybe more, than he ever loved me! It was over-farmed, though. Worn out like all the farms down here. Someone in Washington had a great idea. Kudzu. It was a Japanese plant. Said it was supposed to curb erosion and give zip back to the soil. The Department of Agriculture wanted it all over the South, so Russell went out there and got everyone to plant it on riverbanks and in fallow fields. A crusade was afoot. Kudzu was supposed to be the new king, take up where cotton dropped off. They crowned kudzu queens, they wrote books, they just about sang hymns to the weed. And look what happened. It went wild. Can hardly get rid of it now. Cows can chew it or stomp it to death, and people are forever chopping it up, but it comes right back. It'll swallow up a vacant house in the country before you know it. Grows a foot a night. That's why they call it foot a night, of

course. Wonder if they ever had this problem in Japan?"

Mrs. Rice drove to the rhythm of her thoughts. When she was excited, she sped up; when she was pondering something or feeling sad, she let off the gas. We were coasting downhill, no gas at all, as she mulled over the Japan question. I was thinking about Mr. Rice with his calloused hands, how he probably wore the same smooth khaki work pants my grandfather wore. Mr. Rice would have had a trowel in his hand, a truckload of young plants ready to go in. He was trying to save the land, even if it took a newfangled notion to do it. The road ran in long strips, not curves, but there were plenty of dips and rises.

Heat waves warped the horizon as we reached a crest and could just make out figures moving slowly in the grass up ahead.

"Tick a lock, Sugar!" Mrs. Rice yelled. (This means lock the doors.) I slammed the little knob, so like a golf tee, into its hole and braced myself. "It's those prisoners again. Now don't look them in the eye. They'll just want you to feel sorry for them. And stay away from the window. Scoot over by me."

Outlaw vines and outlaw road crews: there seemed to be a fit there. The men worked in groups of ten or so. Their job was to cut back overgrowth on the side of the road. They were not chained together, but they were prisoners nonetheless. We held our breath as we approached them, as if

saving air would guarantee our safe passage through the arbor of sweaty limbs. They were wielding blades just sharp enough to disentangle the kudzu plants, yet dull enough to be harmless to one another and their somber guards, or so we hoped. Otherwise, there didn't seem to be too much between a blow to the guards' heads and mayhem. What was to say they wouldn't hijack us and run away like their botanical cohort, covering miles before anyone knew what had happened? But the criminals methodically leaned their striped bodies toward the stubborn vine, looked blandly our way as we drove by. No runaways here but Mrs. Rice's and my imaginations. Just a crew of bored, overheated inmates forced to do battle with their consciences and the kudzu.

Mrs. Rice sped up the instant she could. Her knuckles were white and the big vein in her neck was jumping. I scooted back by the window. We didn't talk until our heartbeats calmed down and then only to agree we needed a drink. I peeled myself from the seat and, with triangle-pocked hands and thighs, grabbed two bottles of Coke from the cooler in the back seat.

We pulled her blue tank over and sipped our drinks, chatting about the heat and what she should do about the children who kept stealing her apples. But I wasn't really listening. I kept thinking about the cycle of things: all those earnest men in the thirties courting kudzu as the cure-all, and now these womenless convicts of the seventies married to the task of cutting the kudzu back.

"Sugar, let's say we go home a different way. My heart can't take two passes in one day. I need a nap. You seen enough? You cool yet?"

"Yes, ma'am. Thanks for the drive."

"My pleasure."

Square Flowers

*S*ue is a fearless, independent, middle-aged, nature-loving woman with millions of freckles, long red hair, rubber thongs, and a T-shirt that says *Too Bad Ignorance Isn't Painful.* I was her houseguest—the friend of a friend. We had spun forty miles in her spanking new convertible drinking wine from plastic University of Alabama cups and eating dry roasted peanuts from the jar. She was showing me the sights—offshore oil rigs lit up like floating cities, the dark serpentine mass of a sea wall where she goes birding by day, a Civil War fort looming over the point. Our hair was windwhipped—she wore hers in a long braid that swung from side to side while mine flew around loose. We shouted stories at each other. She told how she prays to God to send a hurricane through that will separate her end of town from the golf courses and resorts that keep encroaching on her peace and quiet.

"My friends say God's going to get me for praying for this sort of thing, but I do it anyway." I could tell this was a theme. She got a divorce, in part, so she could move down to the beach and go barefoot year-round, eat popcorn in bed at midnight if she felt like it. She traveled solo all over the world, and would linger in remote places most women would be too nervous to go. She ran her own travel agency, raised two children by herself, and was very involved in heated, local, environmental politics. There would be no holding her back from anything, including showing me a square flower.

"There's no such thing," I said. "Flowers are curvy. I've fallen for tricks before: I always stop for pennies glued to the sidewalk, and one time I even stopped the car in the middle of the road to pick up someone's lost wallet. Soon

TURF GRASS
OR PERENNIAL
GOLF COURSE GRASS

GOLFICUS TURFA

as I was standing out there in traffic, two kids started reeling this fat billfold into the bushes on a fishing line, laughing, just laughing their heads off. I can look like a stupid tourist on my own. You making this up?"

"No, ma'am. They're small white flowers all bunched together. They stand up together to make a square. Sit on prongs, sort of, almost like big, faceted diamonds. Can't press those for your book, but you oughta see 'em anyway. They grow out here by the dunes. I don't have any in my yard right now, but I'll take you to some."

She squealed down her private road and right onto her neighbor's sandy yard.

"They're weekend people. Don't worry, they aren't home. I just hope they haven't mowed my flowers down. I hate when people mow these coastal yards. They're full of rare flowers and nothing grows tall enough to bother you, anyway." The metal eyelids of her jazzy convertible lifted to full tilt, and her high beams illuminated a smattering of flowers. We got out, engine running, and knelt in the stream of light. Lo, the square flower is a real thing; rough cubes, two or more to each ground-hugging, twiggy stem, each facet chock-full of dry white flowers, just as she'd said there would be. "Go ahead and pick a few. The lawn mower will chew 'em up soon enough if you don't."

I grabbed a handful. We returned to her convertible and soon were parked in her carport, left the engine fan whirring and ticking itself to sleep.

"Thanks for the tour."

"Anytime." She marched off to bed, called over her shoulder as I filled a salt shaker with water as a vase for the flowers, "Hope you find what you're looking for while you're down here. Remember, there's nothing between you and a good time but yourself." No problem. Sue's tangy spirit, to me so southern, was precisely what I was looking for.

False River

*F*alse River is not really a river but an oxbow lake. That's how it appears on the map: a U-shaped collar, minus the ox. This twenty-two mile stretch of water is where the Mississippi River long ago went on a field trip. Floods or shifting geological patterns caused this mysterious arm to drift off. In 1699, French explorers called this tricky river Fausse Rivière; it is located in the Louisiana parish of Pointe Coupée, or Cut Point—I love these literal names. I am intrigued by the slightly mischievous notion that a family could have moved here in the nineteenth century thinking they were to live on the festive banks of a meandering route to New Orleans and the Gulf. They built a cottage replete with gardens and our future collectibles, a cottage destined to be a bed-and-breakfast or restaurant come the twentieth century.

One spring day, the family launched their new boat for the long-awaited excursion south. They happily followed the current through the landscape of lush glades, fields of vigorous sugar cane, and bulging cotton bolls, passing row upon row of beleaguered field hands, and fine homes similar to their own. Just when they would have expected to surge forward, the passing scenery became a closed loop. Their river, it turned out, didn't really want to be a river, it wanted to be a lake. *This is not what we were told to expect. This is the black sheep of the waterway family, the Mississippi's mule-headed offspring cutting loose, a maverick.* Would knowing the truth have changed the depths of love the settlers felt for their new home? After all, False River (the name's an obvious giveaway) could just as easily be True Lake. But would the fishing be more bountiful, the water deeper, or the homes more charming if the words were changed?

The Fall Pilgrimage Tour: Day One

Natchez, Mississippi

The ladies of the Natchez Garden Club of the 1930s discovered an ingenious way to save their ailing pre–Civil War mansions. They opened their doors and charged tourists admission to see what remained of the glorious past. From the outset, the Natchez Pilgrimage, fall and spring, has been tremendously successful. Many homes and public buildings that might have otherwise crumbled or been demolished have been restored through the efforts of this club and other like-minded organizations. While local businesses thrive on the steady flow of visitors, we history buffs, architecture-lovers, and generic tourists get to play pilgrim in a beautiful place.

We are staying at one of the many houses on the Natchez Pilgrimage tour that doubles as a bed-and-breakfast. My mind is at war as we reach the entrance gate: *How can we so frivolously play* Gone with the Wind *when local history is so laden? I hope we have a nice room.* The edifice in question sits on a knoll. It has smooth, thick columns, intricate wrought iron balconies, a family of rockers on the verandah. The flower gardens are fussed-over. The sweeping lawns are dotted with the infamous southern magnolias and dogwoods just turning scarlet and ochre. The brochure offers a "real plantation experience." We don't really want that experience; just a night or two in a hospitable place will do. A scruffy, affable man steps out of a wooden gatehouse and limps toward the car.

"Welcome, y'all. Just drive around to the left and park in back. Please excuse my slurred speech," he says, wiping his mouth on his sleeve. "I've got too much saliva today. But you know if you can keep your saliva flowing, it aids digestion. Digestion begins in the mouth, you know. I never take antacids."

FLOWERING DOGWOOD

CORNUS FLORIDA

He waves us on with a big smile, as if this were the most ordinary of greetings. My husband, Tim, and I look at each other and burst into laughter. Is this man part of the "real" experience?

With each turn on the long, rutted driveway, my grandiose side wins out. *We'll have a bedroom on the second floor with tall ceilings, a ten-ton cherry canopy bed, a porcelain washbasin, a mahogany dressing table, silk drapes. The floor-to-ceiling windows will open onto the balcony where I'll lean out and listen to the birds and the lawn sprinklers ratcheting water onto the grounds. I'll sit in one of these cane rockers and read the novel I've been meaning to get to. Fig trees will grow as high as the iron railings; the figs will be perfectly swollen and just beginning to split with sweetness. I'll pluck them and put them in the washbasin to surprise Tim. We'll feed them to each other like bacchanals. I'll bathe in the claw foot tub, take a cat nap on the massive bed. Dress for dinner—just a simple one-size-fits-all rayon number, Tim will put on that amber sports jacket he wears on vacations. We'll stroll downtown and catch a tour along the way. Belle and Beau in disguise.*

We park our car in the lot discreetly tucked behind the house. It seems so garishly modern and clunky in this setting. We should be in a horse-drawn carriage—which could be arranged for a fee, of course. Tour buses and cars from all over are parked in the driveway. A black woman in an Aunt Jemima bandana sells pralines from a fold-up bridge table on the front walkway (later I decide it's her own business, though, because I see her downtown with her table). We are greeted on the verandah by a gaggle of women in hoopskirts. Yards of organdy, tulle, marquisette, and taffeta sweep along the floor and rustle with their every movement. The women look like unconventionally colorful, walking wedding cakes in their layers upon layers of ruffles and gathers. Their arms rest awkwardly on their gigantic fabric hips. Length permitting, their hair is piled atop their heads, with ringlets curling around their carefully made up faces. All ages are allowed in this show; I like such fair representation. The women alert us that the last tour of the day is starting. Without even first

checking into our magnificent room, we dutifully follow the train of belles into the mansion; they skillfully navigate the doorway, each turning sideways to accommodate her girth.

The tour begins with our proud, elderly hostess, the owner of the house (it appears this enterprise is still in the hands of the women—at least they take center stage). Dressed in her antebellum finery, she sashays across her parquet floors and period rugs pointing out family treasures. *Notice the French this and Italian that. My great-great-great-great-great-grandfather descended from French aristocracy. This foot stool upon which the king's foot once rested has been in the family since the thirteenth century. This screen you see on the Chippendale writing table was placed between an antebellum woman and her candle when she would compose letters. Anyone know why? Because the heat would otherwise melt the heavy waxen make up women had to wear to mask their small pox scars. The painting over the mantel depicts the family plantation before the Yankees burned the cotton fields down. These fields were located across the river in Louisiana. The house we are fortunate to be standing in was the in-town dwelling and was not affected. Now kindly follow Miss Next Guide into the dining room.*

Her cohort carries on: *This shoo fly you see here is hung over the X-century cherry table set with Such and Such bone china and So and So's sterling silver. The shoo fly is a giant wooden fan or paddle rigged above the table and connected to an elegant silk cord which a servant would pull throughout the meal.* (There's that word again. *Servant.* Like *Peculiar Institution.* Maybe if we don't utter the word, it will not have existed. What ever became of the word *slave*?) The shoo fly looks to me like an odd musical instrument, as if the whole dinner table could be played by the slave who pulls the cord. The paddle would simply move back and forth like a giant palm, shooing the flies away, yes, but also stirring the heirloom table settings and chicken bones to a clatter. A peculiar wind instrument. Also the name of a pie. So many sides to a story.

I try to get beyond the Old South script. *Must be hot in that dress, must be*

FIG

FICUS CARICA

a chore hauling that much fabric around, sure am glad times have changed, but no one will let go of the charade until we reach the children's room. The twenty-year-old guide with flawless skin and a slow, sweet voice tells me her hoop is made of flexible plastic so she can sit down if she needs to. She lifts its hem just high enough so I can see the skeleton of her dress. Concentric rings of plastic hold the fabric in orbit about her skinny legs. She is wearing knee-highs and running shoes. The tour comes to an end. All the women are eager to shed their hoops and become themselves again. They flee into a back room and emerge wearing jeans. "Y'all should go to the river. There's a hot air balloon race. Good music, fireworks, tons of food, beer. Go early or you'll never be able to park," our friendly informant says as she runs out the door.

We've managed to extract a tidbit of a story beneath the story of Natchez, but the larger omission leaves us restless. What about those slaves upon whom this luxurious world depended? Tim mutters that someone ought to start the counterpart tour in which everyone has to dig in the fields all day, and stand on the auction block. Meanwhile, he admires the exquisite restoration work and the fact that the town has not become a static tourist trap where no one actually lives. The homes are beautiful and certainly worth preserving. The people are friendly. We are having a good time. But still the missing part tugs at us.

We finally check in to our room. And of course it works out, since we both criticize and participate in this spectacle, that we end up in the servant's quarters. The room sits just over the kitchen, is noisy, dark, expensive, and devoid of character. One couldn't exactly market the slaves' quarters in their original state as desirable accommodations—a single bed, pegs for hanging clothes, a service bell outside the door that's likely to summon you at any moment. No, got to add a private bath, roll out the wall-to-wall, fill baskets with cinnamon potpourri, and then welcome the guests. The more serious pilgrims had reserved the best rooms way ahead of time. Just who are these pilgrims and what are they looking for? Living history lessons or the *if I had money, I*

could live in a house like this fantasy? If I were our hostess, I'd open the doors year-round to pay the exorbitant taxes and upkeep for this family relic, too. I'd wear a costume and memorize, or, better yet, make up for the tourists anecdotes about my museum of a house and my illustrious, maybe crazy, family. I would iron sheets and bake biscuits and sausage and squeeze the living daylights out of oranges if that would enable me to continue to live well along the Mississippi.

We go out for a wonderful French-inspired dinner by the river. Our saliva flows effortlessly while the balloons lift up in the roar of torches. The fair damsels are drinking beer now and cheering their favorites on with abandon. After the fireworks announcing the end of the race, we return to our plain cubby in the mansion where I fall asleep reading in bed, certain that my face will not melt in the lamplight.

P.S. The Magnolia

Could I write a book about the South without mentioning THE MAG-NOLIA in some detail? I don't have much to report about its heady aroma, its huge palm-sized blossoms, its slick green leaves glistening in the sun. While I am visiting, its big ole leaves are so dry they snap underfoot like twigs. The cone-like fruits, the size of your average light bulb, are brown and sticky and split open with vibrant red seeds bursting out. They are huge trees, a real presence, sure to be a major attraction on the Spring Pilgrimage Tour. I can see how the term *steel magnolia,* used to describe the innate strength of southern women, was derived from this tree: it is beautiful, its fragrance potent, yet it is also an enduring, hardy species, just like those women who had the wherewithal and sense of adventure to start these pilgrimages in the first place. I swore I wouldn't use the clichéd term in this book—the steely image is too cold, the contrast between metal and this luscious flower too severe—but I just couldn't help myself. There, it's over with. That wasn't so bad.

magnolia leaf

The Fall Pilgrimage
Tour: Day Two

Natchez, Mississippi

Tim, being a remarkably zestful early riser, brought me breakfast in bed as consolation for being in the boring wing: fresh-squeezed grapefruit juice, tea, corn flakes, prunes (not exactly a fig, now is it?). He watched TV while I picked at my food. No time for reading, no claw foot tub in which to start the day. Instead we packed, paid the bill, and cruised the aisles of the Food Fair until we'd come up with a picnic lunch, thus embarking on another round of tours. So many houses to see, including an octagonal wonder that was never completed because the war broke out. The unplastered walls and exposed beams, bags of nails and scaffolding were left as is. The man of that house eventually died from disappointment, they say. From the work-in-progress we moved on to a neighboring home where there was much parading of costumes, a piano player, and warm biscuits for the guests. Congeniality at its best. It was another dreamy morning for revisiting the splendor of yesteryear—with the added conveniences of 1990s leisure wear and walking shoes.

We'd planned to have our afternoon picnic at a nearby national park. A long driveway led us to sprawling lawns abounding with magnolias, oaks, and cypresses. We pulled over at first sight of a small swamp and claimed our spot in the shade of these now-familiar trees (and we definitely needed shade, even in October). Our closest companions were strange cypress stumps that formed a ring around the muddy little pool. They looked like molten stalagmites. The feathery cypress needles were turning a burnt gold. Sated once again thanks to cheese and tomato sandwiches (I have to eat practically every fifteen minutes

BALD CYPRESS

TAXODIUM DISTICHUM

in order to be good company), we strolled through the park until we reached a mansion rising up behind a hedgerow. It was beautifully preserved and sat on the largest, most peaceful parcel of land we'd encountered so far. I know I repeat myself in mentioning long, shuttered windows, breezy porticoes, and columns, but they are everywhere down South. Especially the columns: if not the authentic smooth plastered kind, cool to the touch and actually supporting the house, then at least decorative facsimiles. This house was more stately than most. It was frozen in time because no one lived there.

The ranger station sat just the other side of the hedge in what was formerly the kitchen. While waiting there for the next tour to begin, we chatted with the park ranger. We told him we were disappointed to learn upon arriving in Natchez that the African American History Museum, slated to open in the former home of William Johnson, a free black man who happened to have owned slaves himself, was boarded up. He sighed with regret that the museum, another park service project, had been caught up in a bureaucratic tangle, but he hoped it would open soon. He promised us that his partner, Ed, would give us a good tour of this home, anyway.

Before Ed arrived, though, the first ranger, in addition to steering us to their good book collection, inadvertently answered a lifelong question for me. He identified that SMELL I've known all my life, yet never bothered to ask anyone about. Whenever my family came South, we would inevitably catch a whiff of something acrid, sour, bitter. I always thought it came from a raunchy plant of some kind. In Connecticut we had a male ginkgo tree that emitted the most vomitlike odor I have encountered in a plant. It didn't seem so far-fetched to think there might be a southern equivalent. I'd even developed a fondness for the smell over the years in that strange way pleasant associations override the truth. Some adults love the smell of rubber cement because it reminds them of childhood art projects or of making ugly little balls to throw at each other, rather than of potential harm; others look wistful at the memory of running

in the DDT cloud released from the bug truck, as if it were Evian mist or powdered sugar, not a poison. For me, this particular bitter smell of the South is forever linked to vacation, my grandparents, the cousins, and huge wedges of watermelon served in the side yard. It carried with it the unique landscape of my youth where even the red dirt was a different color from Connecticut. I'd decided on this trip that the catalpa tree with its huge yellowing leaves was the source; one grew just outside the ranger station and I'd caught wind of old faithful as we walked past it. But when the ranger stepped out from behind his desk with his long spidery legs, regulation shoes, curved shoulders, and sandy hair, and when, with willowy grace, he opened the door to point out where the tour began, he screwed up his otherwise thoughtful face and announced, "Ah, the paper mill has bestowed another fragrant gift upon us."

The paper mill! Of course, that's it. A steaming vat of chemicals and wood pulp. I was both thrilled and disheartened to finally know the truth. So my sentimental memories waft upon noxious vapors. Worse things have happened.

As for the second ranger, he was our dream come true. He was the African American Museum personified, immaculately groomed and buttoned up into one starched and pressed park ranger uniform. We had him to ourselves for the afternoon tour. Ed knew the history like no one else, and he was patient, informative, good-natured, and witty. He began the tour by telling us he has worked at this site since he was a teenager; now he's probably in his sixties. First he was a servant, when the house was still a private home. When the house was willed to the National Park Service with the stipulation that it stay open year-round as a museum, he was given a permanent position as guide. What better person to usher us through the door?

But first he stood back from the front entrance and set the scene. *Picture the antebellum days. Even though things look pretty swank, I want to remind you life was not so easy down here. Wasn't all tea cups and fancy balls. It was hard work. Everyone was susceptible to disease, the poor and the wealthy alike. And I talk about*

the history of the African American. *Not everyone wants to hear that, but if you have me as a guide, that's what I'm going to talk about.* We climbed the wide steps and entered the house.

Throughout the tour, Ed stood at full attention with his hands clasped either in front or behind him. He had seemingly all the time in the world. *See the patterned weave to the rug, the silk wall coverings, the curtains. Summer and winter window dressings. The library of leatherbound books, the photograph collection of various families who have lived here, the paintings, the china, silver, the furniture. A shoo fly. The servants' entry, and so on.* But he added a twist. *Indeed, this elegant living came with a price and that price was paid for by the African American. See this dining room? See this cord the master or his wife would ring for dining service? When the servant reached the table, no one was permitted to look him in the eye because doing so would be to recognize the slave's humanity. Same for food. A slave was not fed proper food because to do so would be an acknowledgment that the slave was a person like the owners. Slavery was dependent upon the idea that slaves weren't really human beings: in order to maintain this institution one had to maintain this belief. Now three-quarters of southern whites had no connection to slavery. Of those who did own slaves, most had one or two. Even so, do you know who King Cotton was? He was a white man who ruled the slaves and the poor white. Of the ten million slaves traded from the seventeenth to nineteenth centuries, more than half of them died en route. That means more died en route than ever lived here. This is called the Middle Passage. People were cramped together in disease-ridden ships, lying head to foot, no room to move. The sick were tossed overboard. Those who lived through the passage often wished they had not. When slaves learned they were headed for the Deep South, they often tried to commit suicide. It was quite a business.*

While he spoke, he was showing us the wide stairways, the polished tropical wood banister, the servants' back stairs, the oriental rugs, the armoire full of gentleman's clothes, a leather suitcase, hairbrushes, shoes, a cradle. *And did*

BALD CYPRESS

TAXODIUM DISTICHUM

you know that a slave woman started giving birth at age twelve to fourteen? This was her job, to produce children who would in turn be trained within a hierarchical system—house servants, kitchen servants, skilled laborers, field hands. Everyone had a place. The roughest life was on the plantations outside of town. Even white women, who wore those large dresses you've probably been seeing all over town, were practically property themselves. Natchez was ahead of the times in allowing women to inherit property. Granted, this could be seen as was a way for fathers to watch after their vast holdings, but the law suited the women all right, since they were often left in charge of running the plantations. Husbands traveled north or to Europe or died from yellow fever or dysentery. So did the women and children for that matter. Women had a lot of responsibility, yet they weren't free to go where they wished. They could not be seen while pregnant, and their children were more often than not expected to be little adults. Put this together with the fear of disease, and you'll see what I mean about things being hard. Though his facts were grave, there was nothing pedantic or righteous in Ed's delivery. He made jokes, asked us questions, laughed. He was simply giving us a thorough tour. (Thank you, Ed.)*

After a couple of hours, we left the hush of closed glass cupboards, drawn drapes, and roped-off rooms. We took the servants' exit, wound down a narrow outdoor stair, and stood in the bright sun. Ed shook our hands and said he'd enjoyed himself, too. He didn't always get to talk quite so much. He'd listened to slave testimonials on tape, read diaries, and researched so much, and he liked to talk about what he knew. His piney aftershave was fast becoming another medium for memory; it was a pleasure to cure this case of historical amnesia we'd felt caught in.

We went back for one last look at the swamp, to rest in the sun and absorb all this disturbing information. We were struck by what happens when you take an unexpected turn in the road or walk through a hedgerow. We almost didn't even meet Ed. Would have driven out of Natchez with our noses glued to history books trying to flesh out the story. Other tourists kept coming and going

as we lounged around beneath the trees, the dried oak leaves standing on their heads in the closely cut lawn, the browned magnolia leaves fanned out around the trunks. The swamp seemed less friendly, more formidable through this new lens. The minivans and sedans cruised along the driveway, turned around, and sped on. They had no idea that they were missing the best tour of all.

People get tired of hearing about slavery. I can hear a southern acquaintance's voice in the back of my head as I write this: *Come on. Are we going to stand around whistling Dixie the rest of our lives or are we going to go on?* I don't know. Maybe it's tiring, but so are lots of difficult subjects. History is inescapably imbedded in this landscape and architecture. I don't mind talking about it. It's an essential leg of this southern odyssey I am on. But get me to the present. I need some air.

Fire in the Delta

We're in the flat, dusty Delta now. Poor, overfarmed, and home of the blues. We're driving circuitously through towns such as Itta Benna, Indianola, Rolling Fork, Alligator, and Mound Bayou on the way to Clarksdale, where we'll visit the Blues Museum. As the highway threads through the landscape, we see deep orange flames blazing toward a wooden house. The yard is full of old cars with their hoods open, clothes on the line, a dead dog on the side of the road. There are no fire engines in sight, but we hear sirens way off. An unmanaged crop fire is taking over. There's a small margin of dry, stubbled lawn between the fields and the house but not much time left. We drive through a scrim of yellow smoke. The fire blows over the two-lane road.

We don't stop to help. We're afraid the gas tank will explode in the heat or that we'll get in the way of the rescue crews when they finally arrive. But what if we all thought like this and an old woman was watching her afternoon talk shows and suddenly. . . . I console myself that whoever called the fire trucks also checked in on her. It's a tiny town, where people must stick together since there doesn't seem to be much to the place besides the people who live here. Old men in worn overalls go in and out of a half boarded-up store or town office. Patchwork pickup trucks are parked up and down the dusty main street; a large, colorful sign in front of a cinder block building announces an African cultural study center. In front of the post office a couple sells vegetables off the back of their truck. The endangered house lies just outside of town. It's really a tinder box. May as well be a sheaf of crisp newspapers doused with gasoline. We drive on.

CAMPHORWEED

HETEROTHECA SUBAXILLARIS

The rest of the way to Clarksdale, I think of what the park ranger, Ed, from Natchez told us: when slaves worked the Delta, there were so many people and animals packed close together, and so much harvesting to be done under intense heat, the slaves would sing to console themselves. The thrum and rattle of so many mournful, powerful voices were known to make the mules drop dead of heart attacks. He said this same power is why slaves were not allowed to gather in groups after dark. I try to picture this scene, but hardly anyone is in the fields around us now. Just miles and miles of hypnotically flat land where sunflowers grow, their golden yellow heads rising up out of the plain. Many more tiny wooden houses, some small as chicken coops or tool sheds, are clustered or stand alone at the edges of the fields. I doubt any historical society is going to raise money to rebuild these homes, and no pilgrimage tours will be pulling flocks of tourists to these quarters. We are a case in point; we're just passing through to somewhere more comfortable. We think this must be the poorest region of the country until we turn on the radio. It is an interview on NPR with Jonathan Kozol, who has just written *Amazing Grace*, about the poorest congressional district in the United States—the South Bronx. He, too, once thought the Delta must be the poorest, most forlorn place, but its fields of growing things and the nearby river seem to offer a sweet respite, something the South Bronx does not. He is talking about how out of such poverty and what he views as societal rejection is born the most intense spiritual faith he's ever encountered. Maybe this faith, along with music, is where the power to survive, even flourish in the Delta comes from. Unlike Kozol, I am too chicken to stop the car and meet the people who live here, to ask them about their lives. How could I expect to have a meaningful conversation as a stranger passing through?

Just outside of Clarksdale, we see a tractor trailer–sized bale of cotton on the edge of a harvested field. Loose bolls tumble beneath a wide open, billowing sky and sunlight reaches to the ground in movielike, heavenly beams. The

bale is tightly capped beneath a tarp. Someone has carefully spray painted the exposed cotton broadside in red letters outlined in black. The paint has saturated the cotton so the colors read bold and clear: IN GOD WE TRUST. We are not religious, but the beautiful synchrony of events makes us reconsider. My faith couldn't kill a flea, let alone a mule, but maybe there's hope, yet. That power lives on.

We arrive in Clarksdale in time to visit the museum, which is well worth the trip. A replica of Muddy Waters sits on a replica of the porch from his first home, another small shack. Photographs of the Delta and all the musicians who have come from here are mounted on the walls: Muddy Waters, Howlin' Wolf, John Lee Hooker, Robert Johnson, B. B. King, and more. Guitars and harmonicas and African instruments, autographed records and other memorabilia fill the cases. Posters from past and future blues festivals hang on the walls. I wish we'd been able to come for a festival. I'm sure we would have seen a different place then. These quiet streets would be full, music would play day and night, history would be in the making, not only hung on the walls and spread out under glass. Maybe I'd get a chance to meet some people, ask them about life in the Delta. Next year, maybe. Until then, I make a studious, though shy, tourist.

We buy a tape for the road. As we leave the city limits, John Lee Hooker is singing about a woman with big legs and a tight skirt who is driving him wild. The blues is an unsentimental sound full of love's woes and life's daily ups and downs, the sweat of hard labor and the humor that gets you through. Not much talk of God, though. More about the devil: running from the devil, being caught by the devil, looking like the devil, or going down to the crossroads. Different side to the same coin—or hay bale, if you will. I bet the thin whine of the fire trucks and the heat stricken field find their way into the sound of the blues. I wonder if they put the fire out in time. Wonder if the spray painter lived nearby or was just passing through, too.

Eulalia

oday is Antimaterialism Day, I proclaimed to myself over a huge breakfast. This meant I would not lust after objects nor spend money frivolously, would not want to be someone else nor envy them their possessions. Wearing an old sweater and toting only a novel, a notebook, and an annotated map, I began a walking tour of Oxford, Mississippi. I intended to appreciate the riches available through my senses: a loamy heap of leaves, the birds chatting it up, a dog sleeping in the sun, snippets of other people's conversations in those delicious southern accents. I would collect only words, images, and memories.

But when I arrived fifteen minutes later at Rowan Oak, home of William Faulkner, I was overcome. If I couldn't outright have his accomplishments and his mystique, I at least wanted his place of refuge. According to Scottish legend, a Rowan oak can bid evil spirits adieu, and provide sanctuary for those who invoke its powers. I wanted Mr. Faulkner's oaks, his cedar-lined driveway imbedded with russet-colored pebbles, and the tree roots splitting off into sandy soil. I wanted his festive clumps of eulalia, an ornamental grass gathered like an excited, swaying choir beneath the trees. I wanted his gardens within gardens—wysteria, rose, magnolia—and the thirty-plus acres buffering him from town. His white pre–Civil War house with its squared columns and no frills would suit me just fine.

Quietly yearning, I entered the house through the front door. A handful of other tourists were visiting. I wondered why these people had come to Rowan Oak. Had they read his books or was it because he is famous, or some

combination thereof? Did they hope to collect gossip? Were they trying to invoke the genius spirit of William Faulkner, get some tips? His yard makes for a good picnic site. Perhaps they came to pay homage to a southern hero. I have come with a certain flounce of pride—southerners are frequently maligned and insulted by people from other parts of the country, some of whom have never even been here. I am relieved, in a sense, that Faulkner was from the South. Though he wrote with a mind toward universal human experience, his novels were peopled with southerners and rooted in his homeland; you cannot think of Faulkner without thinking of the South. For me, his work serves as an antidote, among many, to the curdling notion that all southerners are semiliterate rednecks. *See, good work comes out of the South. There is a strong, irrefutable literary tradition here and Faulkner is testament to this fact.* I've come to see how he lived.

A docent sits in the house and will answer questions when asked, but most people move quietly from doorway to doorway, reading the brief descriptions posted at each cordoned-off threshold. Foyer, living room, library, study, stairwell, his bedroom, his wife's bedroom, his daughter's bedroom. Kitchen and bathroom not included. I started at the living room where his daughter's wedding reception and his own funeral were held, and slowly made my way through the house.

Not much clutter. Nothing flashy or ostentatious. Little to indicate what outrageous, bold expeditions into the English language its most famous inhabitant would take. Just comfortably spare, large rooms. Simple furniture. A few pieces of art: a Japanese doll purchased in 1955, a wooden sculpture given to Faulkner by a Brazilian artist, two paintings by his mother—one of him, I think, another of a local man known as "Preacher." Faulkner made the book shelves in the library. First editions of his own books are casually displayed on a table. His pipe is cradled in a weighty ashtray on the desk, and, next to them, his thick glasses with their heavy black frames are propped open, in perpetuity.

EULALIA GRASS

MISCANTHUS SINENSIS

It is an odd thing wandering around the Great Writer's house, looking at his artifacts. It's as if in looking we could discover *How He Did It*. As if we, too, could write if only we could smoke his pipe, wear his glasses. If we slept in his bed, read from his library, ate from his pots and pans (though we don't get to see those). If in the study we hammered away on his old Underwood, stood by the notes he wrote on the walls with graphite and red grease pencil— what if we actually rubbed against these walls? We'd be thrown out, of course. If I were a man who rode horses, smoked his own meats, hung his neck tie over the mirror of the vanity, who kept tins of liniment and tobacco in his study, perhaps I too could urge words out of my handsome head and onto the page. But any fool knows that copping someone else's style or having a study will not write a book for you.

It struck me as ironic that we tourists were visiting Mr. Faulkner's home, left just as it was when he died in 1964, a home which, as we already know, was his sanctuary. He liked his privacy so much that as he became more and more famous, he built a porch and surrounded it by a wall so he could sit outside without being watched through the front gate. He also didn't want to heat the house, though his wife did. He wanted to live with the elements throughout the seasons. I don't know whose preference prevailed, as my source of information (a book about famous writers' homes on the back hall table) was written in French and I couldn't understand every word. I noticed Rowan Oak does have air-conditioning, though. I wonder who installed that, and when.

Though I was enjoying my visit (as evidenced by the aforementioned desire to have), a familiar feeling came over me. Sometimes I would prefer not to know anything of a writer's private life, especially when I know he would rather I didn't. Similarly, I would rather not see a movie of a book nor hear an author read live before I've read the book. I can't read the same ever again; I forever infuse the narrative with the character standing at the lectern, or glowing from the screen. *So and so has an unfortunate habit of reading into her cowl*

neck sweater, and he seemed irritated with the audience, as if we were keeping him from a wedge of Cheddar and a box of water biscuits. The way she cleared her throat, the way he nervously brushed his bangs off his forehead, his fetish for ironing his money, her six marriages, how exquisitely swanlike her neck, how mesmerizing his voice rising up from the page. This small bundle of information teases me into thinking I know something about an author when in fact all I really may know intimately is what I have read. The work itself. Perhaps so it goes with authors' homes, as well. Enough of the house. I'll go read in the garden. Leaving by the same door—for good luck—I headed for the perfectly centered magnolia tree at the end of the walk and beside it those magnificent, ephemeral grasses.

I was reading *Absalom, Absalom* in the sun. I began to think Rowan Oak was the house of the main character, Sutpen. I blithely assumed these gardens were planted by Sutpen and his family before the Civil War broke out. That the barn sheltered his black steed. That Faulkner inherited this place after it was volleyed for years between his characters. *How strange. I think he is the stuff of his imagination. I bet this is a common experience. It must be the power of his writing. The reader believes so wholeheartedly in the world set down on paper that they forget it is fiction. They feel they ought to be able to go "there." To stroll through an otherwise ordinary neighborhood in a thriving, friendly university town, circa 1995, then pass through the gate, knock on the door, and sit down for a Reconstruction-era breakfast of cornbread and greens with Sutpen, Clytie, Judith, and Rosa.*

Eulalia. Ornamental grasses originally from China. *Miscanthus sinensis.* The common name could easily be that of one of my ancestors—Lucretia, Eula, Aurelia, Eulalia. The grasses look like a gaggle of children or puppies, those ecstatic choral singers again, bowing to the crisp day. Their heads are tassels or feather dusters on a stiff narrow stalk, each one pulled flat-backed,

face-forward to the ground. The neighboring plants are those you would expect me to collect as a memento of this excursion. The oak would be the most obvious choice. Or the cedars. Faulkner frequently mentioned wisteria. Not even the magnolias, though these huge trees are impressive, grab my attention as much as the grasses do. This broken stalk, now a small breathy wand, will be my souvenir.

Did he plant Eulalia himself? Did she live here with him long? I intended to ask the gardener, who had been sweeping dead magnolia leaves into a plastic garbage can, but he slipped away while I was reading. I hoped he'd come back soon; I'd only just noticed him so unobtrusively tending the plants and then he was gone. Leaves curled and tumbled and scattered on the lawn: he had plenty of work ahead of him. Eulalia's seeds would be airborne soon, too. That's one of the things I liked about her, her now-you-see-it, now-you-don't quality. If I handled Eulalia too firmly, she was gone—in the ephemeral way of the imagination.

A few chapters deeper, my bottomless stomach longed for attention. It was time to leave the writer's museum. As for my ambitious proclamation, I realized as I stretched on the lawn there is an important difference between hoarding and appreciating, imitating and admiring. *Thank you for a good morning, William Faulkner, southerner at large, perhaps you are some conglomeration of your many characters, after all. Who cares, really. I wandered through your rooms, I lay in the sun and enjoyed your garden, confirming for myself that while I too need a refuge, a smaller one will do. And I will tussle with my imagination to write my own books. But speaking as an incurable materialist, your world—what I know of it—is still an enviable one.* I gathered my things, old and new, slipped out through his gate, and went downtown.

Walking Double Time

What strange spell has been cast over this town? The young men are working in the bars, the bookstores, the restaurants. They are fixing flat tires and studying. Don't really see much of them on the streets. How do they keep in shape, one wonders, since the sidewalks are only full of young exercising women? The walking women of Oxford, Mississippi. They walk in pairs or trios, though I hesitate to call it walking at all; more a cross between a horse's canter and a young soldier's first awkward drills, or the half-run of a teacher's pet who doesn't want to get in trouble for running in the halls but goes to the brink of being bad with this brisk, jerky gait. They cut right angles around the picturesque town square, parading before the world's best bookstore, an old-fashioned downtown department store, a men's clothier, a fabulous nouvelle cuisine restaurant, a contemporary art gallery, and so on. They never break stride, even as they chat. At first I think I'm seeing the same pair over and over, that they cannot stop themselves for all that collegiate vitality. I feel old just watching them. But after ambling around the same picturesque square myself, I realize the pairs are ever-changing. I feel better.

They must be after the endorphin rush that running promises but not the injury it so often delivers. A sharp crease at the elbow, a studied lilt, and they're off. They are the best-dressed people I've ever seen break a sweat: even the free weights some of them carry are color-coordinated with their sunny yellow and white exercise outfits. Their smooth legs are freshly waxed or shaved, manicured hands pump vigorously at their sides, and, despite their

YELLOW MYSTERY
PARKING LOT
FLOWERS

sweat, they leave a fragrant wake of just-washed hair and brand-name soap. I overhear a man in the bookstore suggest *the sororities put the girls up to it. They must earn points or something.* Points for fitness, comradery, grooming, discipline, and cheerfulness. They should earn extra for mystifying and impressing tourists, especially those of us who were always too moody and sedentary and rebellious and scruffy to join a sorority.

Phillips Grocery

*W*hat we ate for lunch (everything served in waxed paper sacks):

Fried okra
2 orders of spicy french fries with catsup (ordered one, then
 another as soon as we finished the first)
Fried catfish fillet sandwich
Double hamburger (1/2 pound of meat in two hand-shaped patties)
Iced tea, unsweetened, with lemon, in a very large paper cup
Coke in a bottle
Homemade fried apple pie
Peppermint balls

Total price, including tip: $9.00

okra

Where: At the old roadside grocery store over by the cotton compress and the railroad station. Go past the Holly Springs Courthouse on the town square, down the divided road with trees up the center, bear right when you get to the compress, which is the building with rippling corrugated steel siding. It's been patched up and painted in more shades of red than you can imagine. Go parallel to that building till you get to the railroad tracks. The depot will be on your left—there are still trains running, so be careful. The grocery's on your right. There are a couple of picnic tables out front on the cement patio and the name is painted on the window: *Phillips Grocery, established 1949.* Vintage advertising signs are everywhere, inside and out. *Dr. Pepper. Enjoy sugar-free Diet-Rite cola. For smoking enjoyment, Camel. Dixie Boy drink flavors. Coca-Cola. Dental Sweet Snuff.* There are ceiling fans and ice cream parlor chairs with curled metal backs inside, there's even a yellowed map of the world on the wall, but there's nothing cutesy about this place. Everybody goes there just to eat or take out. It's the unadulterated, greasy thing, and it's good.

Forget-Me-Not

*D*ear Elvis,

 You are not dead, not as long as your number one fan is still alive.

 I thought I'd let you know, in case you didn't already, that a man in Holly Springs, Mississippi, has created a shrine for you. I visited it with my husband, Tim; we are fans, both of you and your devotee. This humble and impassioned man has dedicated his life to your memory by collecting every scrap of information, every souvenir of your life he can rustle up from this earth from which your body, anyway, has departed—or has it?

 It was a cool day in October that we drove up from Oxford to see what was going on in Holly Springs. We'd read about the shrine in a guidebook to unusual sights throughout Mississippi. (Paul, the devotee, calls it a dedication, not a shrine, but believe me, they are one and the same.) We'd also heard that your number one fan and his son had given a talk at an Ole Miss conference which focused on none other than YOU.

 It was a short drive through faintly turning autumnal leaves and thick patches of evergreens. The sky was open and cloudless. We followed the guidebook's easy directions to East Gholson Avenue. It was lined with orange-leafed popcorn trees—tallowtrees, really, but they're called otherwise because their white seeds look like popped corn. The chinaberry trees were full of berries, many of which had been scattered and smushed, leaving yellow stains on the sidewalk. At the end of the nothing-fancy residential street, we spotted the old house with its indoor-outdoor carpet on the front steps, and two stone lions next to a pair of columns. Twin black iron benches sat on either side of the

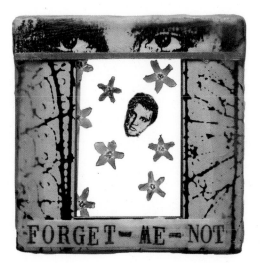

TRUE FORGET-ME-NOT

MYOSOTIS SCORPIOIDES

door, and two identical posters of you were taped to the windows over the entry way. We parked against a cracked curb. The house stood cocked slightly off-kilter in the full sun. No one seemed to be around. In the stillness, the birds suddenly seemed loud, the far-off traffic a steady flow to somewhere. A store-bought YES WE'RE OPEN sign was tacked to the house, as were a couple of handwritten posterboard decrees: *No Drinks on This Property* and *No Videos*. A bread box–sized sign stuck in the front yard told us in a careful script that we had arrived at "Graceland Too."

We rang the doorbell and your devotee's twenty-something son—named Elvis, of course—greeted us. He is a large young man with an unwavering, grown-up gaze. He's been immersed in his father's devotional act his whole short life, as we learn on the tour, and I imagine he's met all kinds of folks in his tenure as guide. Graceland Too is open to everyone, 24 hours a day, 365 days a year. They charge a nominal admission fee; after three or more visits, one becomes a lifetime member. Such privilege allows free admittance forevermore and the honor of putting on your sexy leather jacket and having a picture taken in it. I intend to become a member as soon as possible. Our host plans to have a party for the lifetimers someday.

Elvis Too thanked us for our money and moved us quickly from room to room as if he really needed to take a nap—he was not disinterested, merely worn out. Seems Graceland Too has been getting a lot of attention lately; a TV crew had been through last night, and the night before that a busload of Japanese tourists pulled up around midnight. This family must get interrupted at all times of the day—in the middle of a bite of toast; one shoe on, one shoe off; while brushing their teeth. Paul later tells us that he sleeps on the floor of the living room/video room in the wee hours of the morning because this is his only lag time.

Fatigue aside, Elvis Too politely talked us through the archives. *These racks you see here in the entrance hall are full of every* TV Guide *that has ever mentioned*

Elvis. They are coded with these colored paper clips according to whether Elvis actually appeared on or was mentioned in a show. Here on these shelves we have every forty-five Elvis ever released. On these shelves we have as many publications as we can find that have featured, mentioned, or pictured Elvis in any way. Included in this section are 20,000 or so newspaper clippings. Any more questions about this room? he asked as he pointed one stocking foot toward the next shag-carpeted room. I didn't want to ask him anything because he didn't seem to have the strength to dawdle, but I'd like to know if he's in college, does he want to do the shrine thing, does he love you like his dad does? Is he an Elvis impersonator? What does he think you, Elvis One, would make of this dedication?

We were standing in the video room where, as Elvis Too explained, several TVs were running at all times, so that if you air in any way, shape, or form, whoever is on duty can record the show, advertisement, or movie. Paul emerged as we were standing amidst the trunks and trunks of videos in the living room, which could have been mistaken for a colorful rations pantry with all these trunks stockpiled against the Elvis posters and album covers. But instead of freeze-dried beef or canned lima beans, we get hours and hours of YOU! Elvis Too introduced us to the senior guide and ultimate keeper of this archive and excused himself, hopefully to catch some sleep upstairs in the realm where no visitors may go. Maybe he walked the dog, Lisa Marie, or went out for groceries. Paul's black hair was wet from a shower; he was combing it back with his fingers while snapping his black Elvis-style western shirt closed. He is large, too, but is shorter and rounder than his son. He wore black pants, black socks, and long sideburns just like you wore in the later years. He shook our hands, looked us in the eye, and welcomed us to his home.

Paul has an encyclopedic knowledge of your life coupled with a religiouslike fervor for tending this dedication. He rattles off when you were born, where you lived, who your parents were, what you recorded when, the time line of your amazing career, and what you played at various concerts. He talks

about you and the collection so much now with all the attention he's been getting, that he needs hard candies to keep his mouth lubricated; he offered us a red and white striped mint from his private stash. The buses of tourists at any hour of the day or night; Ole Miss students coming in jovial bands; *Current Affairs, The New York Times;* curious stragglers like us; everyone keeps him talking about his favorite subject. He listens to the radio, reads a lot, and calls up DJs and journalists to correct any inaccuracies they may have reported about you. He says the original Graceland sends guides-in-training to his place to witness his collection. As an ultimate indication of how visible he's become, Disneyworld supposedly wanted to buy the whole house and everything in it to bring to Florida, but there would be no Graceland Too without Paul and Elvis Too. Not without Holly Springs and the spokes of people ("coincidences") that link you and Paul. The man who tooled your belts lives nearby. So does the man who took care of your cars, the woman who changed your diapers, and the guards who looked after you. Everyone lives within walking distance (if only Paul walked anywhere—he hardly ever leaves Graceland Too, you see). Divine providence has brought them all together and kept them within easy reach. To complete the karmic wheel, Paul is expecting the real Lisa Marie and Priscilla to make an appearance soon. Their chauffeur came by recently, told Paul the seats in the limo were still warm from the mother-daughter team. Can't remember where they were going, but they've yet to brave the entrance into the house. Maybe you could let them know somehow that he's a good man, that they'd be moved by the experience.

I got the shivers from Paul. He sputtered and grew breathless with enthusiasm for you. He spoke at such a pitch, so complete is his devotion to your legend that I half expected you to come through the walls in a mist, to hover over Paul's shoulders and comfort him, lead him to new artifacts, reveal never-told-before stories about your intimate life, and sing lost recordings. He spoke like a small boy who has discovered a secret tunnel, or a cave full arrowheads. He

is a man who has been touched and can't wait to spread the good word, to describe everything in order to make it real, as if he can hardly believe it all himself, this marvelous phenomenon that was, and still is, Elvis Presley.

Did you know he was outside your house every day the month you died? He took the last footage of you with a home movie camera—Elvis on his Harley. When you were rushed to the hospital, he followed you there, stood outside the emergency room door and broke the news with tears in his eyes to his then-young son that they were never going to see you again. The greatest regret of Paul's life is that he never got to speak with you. He was close lots of times, saw you in concert 125 times. But your guards were always surrounding you. They—maybe you, too—were afraid you'd be assassinated. Who knew you would end the way you did? Why did you get into all those pills and such? Was it just a heart attack that got you?

Paul showed us an aluminum single he'd recorded once of himself singing "All Shook Up." He held it in front of me, pointed out the label, then showed me your version. Played yours, then played his, then sang inches from my face so I wouldn't doubt those lovely, absolutely perfect Elvislike sounds were coming from his very own self. I believed I was in your presence, Elvis, so perfect was his rendition, so intent were his eyes as he peered into mine. We were all shook up.

Forget-me-not, you might say. No possible way that could happen here. Paul claims he was even trapped in the mausoleum with your body for several hours. Did your soul go into his body? Are you hiding out in Holly Springs at that scratchy but hospitable corner lot? A convenient drive from Graceland One and Tupelo, your birthplace? A two-second drive to Phillips Grocery, that restaurant everyone loves so much? Did you like hamburgers, Elvis?

The last room on the tour was a bedroom in which Paul's mother was sitting. (She, Elvis Too, and Paul live in the house together and work as a team. Mama sits in the front bedroom by the window, this last room on the tour, and

alerts the other two when visitors arrive. I guess she told them when we arrived, though we didn't see her till the end.) She sat in a rocking chair, smiling sweetly. Her hair was teased in a neat cap around her heavily powdered and rouged face. Her plastic hairbrush lay on the bed beside one of your show costumes. Standing next to her was a cardboard cut-out of Elvez, the Hispanic performer who sings Spanglish renditions of your songs. He's been to visit several times. Tim asked her what she thought of Elvez. She's hard of hearing, and answered like a well-mannered, trained parrot.

"Oh, yes. I think he's the greatest singer that ever lived."

Paul said, "She can't hear well." "No, no, not Elvis, Mama, Elvez."

"I like him, too. A very nice man." We all chuckle. They are a generous lot at Graceland Too. Anyone who loves Elvis is a friend of theirs.

Before leaving, we had our pictures taken next to a blow-up portrait of you. A vast array of photos of everyone who has visited hangs on the walls throughout the house. Paul offered to sell us a scrap of your carpeting sealed in a Ziploc bag—I think it was from Graceland's Jungle Room, which you supposedly designed yourself. Paul spoke throughout the tour of the escalating value of his collections, but he won't part with much beyond the scraps and access to the TV show archives. Of course, he must charge the film crews to come through the house. He gave up a new house, a wet bar, a pool, a car, maybe his marriage, and a lucrative union job to tend to his collection. He'll not let go of it for anything. Not the photographs of you, the King, your Liberace-like bell-bottom costume, your thick, jeweled outer space belt, old albums and their covers, tickets from your last performance, petals from graveside flowers. He followed us outside and thanked us for coming to see Graceland Too. We congratulated him on a job well done.

Forget-me-not is a tiny flower that grows everywhere: along cement curbs, around telephone poles, beside patio furniture, by the front door and the back

in Holly Springs, Tupelo, New York, and California—any place where some-
one hasn't sprayed with Round Up or hoed you to bits. You and forget-me-not
are both household phenomena; one a sweet little purple-blue flower with
yellow eyes and a terrifically appropriate name for this fan letter, the other an
enigmatic performer and sex symbol. What I won't forget about you: those hyp-
notic eyes, your crooning voice, those moves, that twitching curled lip, that
pouting mouth, the legend of you, what happened to you (I prefer to remem-
ber the slim years), the fans.

The tour was one-and-a-half-hours long. By the time we'd left, Tim and
I realized we'd been so engrossed we hadn't even looked at each other once
during the entire visit. We sat dumbfounded in the car, asking ourselves *What
was that? What did we just do?* That's when we decided to tank up at Phillips
Grocery. We mulled the experience over and decided you are in good, though
highly obsessive, hands. We only hope Paul has a sprinkler system in the house
in the event of a fire.

So you see, Elvis, even if you wanted to be dead, there are legions of fans
who won't let you go. They would do anything to have a sighting. Our host
even said in utmost seriousness that he'd give his life today if doing so would
bring you back for all the fans. Did you feel so loved when you were alive, or
was it precisely this kind of adulation that drove you over the edge? Did you
want to be just a regular guy in the end? Whether you receive this fan letter or
not, I just wanted to document what incredible work you have inspired in oth-
ers. I hear Graceland is a fine museum and a well-oiled corporation that looks
after your interests, but Graceland Too is an impressive, loving tribute that
deserves your attention. Hope to see you at the big party.

Sincerely,

Ann P Senn

WATER TUPELO

NYSSA AQUATICA

Tupelo and Bald Cypress

Tim and I have been driving for hours on the Natchez Trace, an ancient trade route that runs roughly from Memphis, Tennessee, to Natchez, Mississippi, and is now a gorgeous parkway operated by the National Park Service. We heed each sign announcing significant historic events or natural phenomena. We've seen the prehistoric mounds, a scenic overlook, a pine forest, Native American artifacts, and an old camp for travelers on the original trace, now a wide, wooded path winding ghostlike back and forth across the road. Now we have reached a swamp, which I've been looking forward to all day. We stand gazing upon an otherworldly forest. I half expected to find a TV version: criminals fleeing the authorities through dangerous waters; a hero skimming the mysterious terrain in a fan-powered boat as he rescues lost pets or thwarts an evil-doer; slaves escaping through miles of soggy land. But now that I'm actually here, I find nothing foreboding or sinister. It doesn't even stink, at least not in the fall. New adjectives queue up in my head: serene, fertile, enigmatic, lush. Even the park service signs wax poetic as we begin to cross the swamp on a boardwalk. They suggest we take our time along the trail "so the magic can unfold" and in order to "meditate on the details." Captions and annotated pauses: where would we be without them? Making uninformed, metaphoric hash of things, I'm sure.

The water is a dark brew with a thick layer of green just barely moving on its surface. The green is that of new shoots, of a floating exotic salad, of 1970s air ferns, or AstroTurf. The plants swirl and curve in on themselves until the water's surface resembles an aerating paisley or an old book's marbled end sheet.

The cypress and the tupelo are the "two revered patriarchs" of this site. They are haunting at first, obscuring the light as they do. They emerge from the water with bulbous trunks and striated watermarks: dark, darker, darkest bands of green and brown. Where water and tree meet is an astounding visual puzzle; we don't expect to see trees growing beneath the water's surface, where no land plants dare to go. Other trees would have long since rotted in these conditions, but cypresses, in particular, have been dredged from swamps and then used for building. A full canopy formed by the patriarchs casts a diffuse sepia and green light over this wild basin. (What is a swamp, anyway? Is it fed by a river? Is it a sluggish tributary? A cut-off meandering flow, or a sleeping river fast on its way to becoming a lake?)

The surrounding brush ticks and hums with life. I try to identify a thing or two. A minute herd of insects is making skeletons of the leaves. Grackles and frogs cheer each other on in their hidden pursuits. Small black birds swoop between branches and vines. Herons do their lithe strut. Fish jump and sink out of sight. Turtles must be out there, and snakes, too. Sweet gum balls hang from the tree like prickly Christmas ornaments or earrings. Are the balls luring birds, to disperse their cache of seeds? Are they hanging out until they are fecund enough to drop and be washed away, buried, swallowed, and defecated by other beasts? This swamp is a bustling plein air dining room/bedroom. Nature is anything but quiet.

We walk to the edge of the herbaceous stew and look for the small alligators that the signs claim live here. Despite their reputations, alligators aren't vicious and still fear humans. They are said to look like floating logs with eyes, a perfect disguise in this tree-studded pool. We never see one. I have an urge to stir the sludge with a big stick just to see what would happen, but the surface is perfectly covered—that paisley again, the most exquisite melding of colors and shapes—that I cannot bring myself to create a disturbance. I want instead to make wallpaper, upholstery fabric, and linens of this moving sheet of textures,

BALD CYPRESS

TAXODIUM DISTICHUM

the varied greens, browns, and beiges, the elliptical tupelo leaves and the spindly twigs suspended on tiny green water plants. What stunning contrasts. Why must I see everything as a spin-off, a human product, and not simply for what it is? On second thought, the best designs often come from nature anyway: more than flattery, imitation is a form of reverence.

As we continue to meditate on the details, we notice what look like cypress stumps in the distance. At first sight we assume not only do cypress trees go bald (their name refers to their winter state), but they also turn into sickly nubbins and die in strange, idolatrous formations around the papa or mama trees. Thanks to our friends the signs, we learn the stumps are actually "knees" which help feed oxygen to the roots. The knees jut out of the water like so many sunken fishermen whose legs are forever bent above the surface. Fishermen with Aqua-Lungs and a jazzy technique. Or like an odd jumble of orderlies sucking in the air, little druids, little pagan seekers, stalagmite foundlings, cult members, devotees at Lord Cypress's feet. The cypress leaves, by contrast, are delicate, deciduous, cilia-like spines, like flat centipedes.

sassafras grows in the swamp, too

The more time we spend here, the more we notice our metaphors mounting. We make slightly informed observations rather than totally-in-the-dark mishmash. *The tannic acids and microbes keep the water clean for the benefit of the trees and other life forms. The bulge at the bottom of the trees helps support them since their roots are shallow.* But in the end, our clumsy language is embarrassing. Snow: powdered sugar. Swamp water: stew.

Tupelo trees: brown celery stalks. Ecosystem: terrine. These analogies remind me of taking the SATs.

All this densely interconnected stuff of life, so thick and slow, and here we are in it, a man and woman in factory-made clothes, a purse with a car key in its craw, imported shoes, a sheaf of paper, luggage in the trunk, and a plane ticket to a bustling city. What have we to do with this sludgy, beautiful empire of plants and animals, an entire ecosystem? We know we are connected to this place by virtue of being another couple of earthlings, but still we feel so apart. I need familiar words and images. At the tourist signs' promptings, we pause at the appropriate moment, and are happily oriented by our free-ranging associations. With time, silence, and some reading, maybe we'll begin to notice things a bit more on nature's terms. Meanwhile, we get back in the car and follow the trace to Jackson for some easily recognizable, human culture.

Here Is a Chicken

We've left the Natchez Trace, gotten lost looking for a restaurant in Jackson, fought over how to read the map, and given up. *Oh, let's just get back on the highway and find something on the way to Alabama. Fine. That's just fine. Don't blame me if we can't find anything you like.* We see no restaurants. We are skirting the edges of a national forest. Acres and acres of pines convene before us. Our prospects look bleak as we draw closer to the woods. Nothing but squirrels and the lofty trees with their pungent resin, scaly bark, elongated needles, pollen clouds, and keeled cones. A last-chance sign advertises parkside dining. Great, a blue plate special here at the forest's hem.

We eagerly exit the highway and find ourselves on a commercial strip— there's a truck stop with big rigs snoozing in the sun, a dirty gas station, a video rental store, a scruffy lumber yard, and a small propane gas company. The forest rises up behind the buildings. We look toward it, searching for a gold-lettered sign at the head of a winding driveway. We are expecting a well-manicured lawn, and a small crowd parked in the distant lot. The guests will eat cheaply, but well, on the patio. They'll listen to the wind whistle through the pines on this fall evening. We long for a clichéd tourist moment. No such luck. The restaurant is missing.

Why couldn't we just have gotten something back in Jackson? You are impossible to travel with sometimes.

You read the map then. You weren't any better at figuring out where we were. That map rots, that's why.

The strip peters out, the trees recede into the background, and the road

leads us to a poverty-stricken downtown that has been blighted by recent fires and a fading timber industry. Seems one of the few businesses left is a poultry plant tucked between the strip and the charred remains of a Woolworths. It's a large, fenced compound of wooden, yellow-lit hatcheries, long row houses for growing chickens, and a dusty loading dock where trucks groan in and out. Employees come and go, even walk around town wearing regulation jumpsuits and hair nets—no one looks twice in a company town. The only food we manage to find is from an unhappy-looking Dairy Queen, her kingdom having dwindled and suffered around her. Tim orders, appropriately enough, two grilled chicken sandwiches and I sulk over a large order of onion rings. We continue in silence toward Alabama.

I notice a white something on the shoulder of the highway. Is it a shopping bag, a pom-pom? It's a whorl of feathers. White, white feathers fanned like a headdress from a cheap roadside souvenir stand. Moments later, another whorl. Now I see a chicken's bare stippled legs held together by metal bands. And again, as if at perfectly timed intervals, the chute (a broken wood crate) opens on the over-stuffed poultry truck in front of us. A panicky chicken falls pell-mell through the air and lands on the road where it dies on impact. The driver is oblivious to what has begun to happen. By the time he arrives at his destination, he'll have a very light load. Apparently, even tethered birds can fly the coop. We blow the horn to warn him, but he doesn't notice us.

Instead of following a trail of bread crumbs, we follow dead chickens through the forest and out the other side. We barely notice the landscape for the spectacle. Finally, fifteen miles and seven birds later, the truck veers north toward Meridian and the chicken plucking plant. No sooner do we begin to relax than we see a sign for one of my ancestral homes, a place I have never been. I've been hearing about Chunky forever, birthplace of my paternal grandfather, and home to his spirited family. I've always wondered why anyone

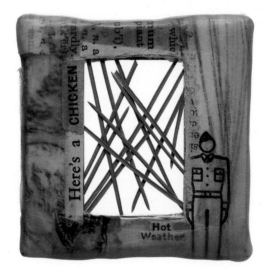

LONGLEAF
YELLOW PINE

PINUS PALUSTRIS

would name a town Chunky. The neighboring town is Pine Apple; in my child's mind I pictured juicy servings of chunky Dole pineapple. To me, Chunky was a faraway sweet wedge of land. Now, unexpectedly, here we are taking the exit.

The pine forest thins out to soybean fields edged by a few trailer homes and the naked foundations of pre-fab houses awaiting their walls. Closer into town are a few older houses in need of attention; bowed roof lines, a clothes-line drooping between hickory trees, those springy, heavy, old metal lawn chairs rusting in the yards. Before we know it, we are "there." It's 4:00 P.M., down-town Chunky. A father and his two little boys, in striped smocks, glow under the fluorescent lights of a barber shop; the garage door of a tidy auto shop is scrolled down and padlocked for the night; a falling-down restaurant across from the barber shop grows a toupée of grass. An eighteen-wheeler idles between the restaurant and the train tracks while the driver studies the map—another disoriented, hungry visitor. Could this really be all there is to Chunky?

There is nothing here to tell me what I want to know: where was my grandfather raised, where is that storytelling porch and the gristmill my great-grandfather rigged with an old Ford he'd bought to visit all his children in, but used to power the mill, instead? How did his voice sound? Where are his bushy moustache, his overalls, and his good will? And did he ever know about his own great-grandfather in Weston (see "Confederate Jasmine")—the New Hampshire man who started this southern chain of descendants? Where did Mama Lewis do her quilting or hang her cotton dresses to dry? Where is her kind face and round lap? Where did she come from? Who were her friends? What did she think about as she went to sleep? Where is my grandfather's youth? What became of his many brothers and sisters? I'm looking for *live* chickens and a large vegetable garden, a small wooden house bursting with people dressed for a Sunday visit. I'm looking for a different time.

This urge to harvest facts and anecdotes can be all-consuming. I could spend the rest of my life finding out who was who, what was what, when,

where, and why. I am reminded of what I once heard a man at a party say of people who are into ancestor hunting. *Such people are like potatoes: the best part is underground.* I don't agree with him—a nightshade has its moment in the sun—but I do wonder where the limit is. The people whom I always thought would be around to keep things straight, to know the family tree, pluck its fruits and prune its limbs, are not immortal. The full flush of this realization comes over me as we drive through Chunky, lumpy Chunky, in the valley of the chicken, the pine forests, the sad queen, and the family long-gone. I suddenly want to photograph every inch of town, bottle the accents of the oldest generation before their melodious regional voices are homogenized—it used to be that southerners could hear a difference of county, let alone state, in each other's accents. I want to gather and faithfully document everything. But I would surely go crazy, and for what? To commemorate the quiet, persistent history of a people and a place? To fix myself, like a buried tuber, to the South?

Family, the living kind, is expecting us in Alabama within the hour. We turn around at the Chunky Cafe. The roof is caved in almost to the floor. The asphalt shingles are within easy reach. Vines have claimed the cafe fair and square. The sign is the only sturdy structure. It beckons travelers who don't know better. A warm meal, at last—three boiled vegetables, a meat, and corn bread at the counter—just two dollars away. Melancholy and impatient to reach our destination, we join the thin stream of traffic moving toward the highway and leave the past to itself. We agree road trips breed discovery—that's why we like to travel—though, obviously, not all discoveries are welcome. But think of the animals that will be out tonight, incredulous at the strange roadkill come their way. We drive the rest of the way in relative peace—free of such lurid, unnecessary mile markers. I already know the way to Alabama, but thanks anyway.

The Palace of Junk

elen and her husband Ricky live on a rural route in Alabama. I've always wanted an address with "RR," a highway number, or "Star Route." Makes me think of quiet, a world without streetlights, *Star Trek*, *Lost in Space*. I did get lost when I visited her. I missed the landmarks (take a right at the stand of pines just after the water tower, a left at Uncle Jazz's Grocery). But getting lost is a good excuse to talk to people. This time it was a teenaged fitness walker (a common sight these days) in a peach, crepe paper–like walking suit, very white shoes, and fluorescent sports socks. Her blunt-cut strawberry hair had a perky swing to it. She pointed down the road with her long, coral nails.

"You're going to Helen's house? She's my neighbor. Just go about a mile and turn left when you see the gigantic satellite dish pretty near the road. That's my parents'." She rolled her eyes. "Are you Helen's sister? You sure look like her."

"We're distant cousins. It's the large forehead. Everyone this side of the family has a receding hairline."

"Just means you're smart. Say hey to Helen." She looked right at me, without a trace of shyness or caution. I can't get used to such overt friendliness. I never know if its real. What does she say later to her mother in the kitchen or to the man next door? *Some dumb woman from out of town who's losing her hair like a man got lost.* Can people really be this relaxed and friendly? Even if they don't mean exactly what they say, at least they make the effort to be gracious. Besides, she called me smart and she has soothing, clear eyes.

"Would you like a ride?" I asked, hoping to talk with her about being a

teenager way out here among the mile markers. What does she do for fun? Certainly not this manic walking. Where does she go to school, what does she long to do?

"No, thank you. I need to walk—too much eating."

"Alright. Thanks a lot." I waved to this beautiful young woman as I drove away, and I remembered that adolescent itch to improve oneself, to banish any trace of imagined weakness or imperfection. What a relief to finally like myself as is, creases, blemishes, and all.

When I got to Helen's house I told her the neighbor had given me directions.

"Suzy Bee. Bless her heart. She's a queen in a pig sty. She's only eighteen years old, lives with her mama and daddy, Mary Stewart and Roy. They are the nicest people, but come on. We'll take a walk out that way. I can't describe it; you'll have to see for yourself. Can I get you something to drink first? It's so good to see you again." We had iced tea while she talked.

"The Dartwells, well, you'll see soon enough, they don't mind a mess. Except for Suzy Bee. She's embarrassed by the family. Her figure is perfect enough for an underwear ad—she tries to get me out there walking with her but I feel like a tuba next to her. Between that body and her big white teeth and her cute face all the other girls hate her and love her. I've watched the whole thing—I teach at the high school, you know. They all want to be her, of course, and they talk ugly about her, too. Everybody talks about her house. All that filth comes down to one question for me and Ricky: Who is going to dare to date Suzy Bee? No scaredy cat. That boy is gonna have to put up with the slob-bery dogs and the cat tee-tee at the front door. The doorbell doesn't work, of course—the house is barely standing, so how could the tiniest wire in the house lead anywhere? It was beautiful a long time ago. Has three stories, stained glass windows, columns, and a carriage house, even a dumbwaiter, but it looks like crud now. That boy is gonna have to practically bang down the solid wood doors—it's hard enough to ask the most beautiful girl on a date, but to have to

QUEEN ANNE'S LACE

DAUCUS CAROTA

reach her over the TV or the radio—too much. The dogs will bark when he gets near, but they always do. No one in the house bothers to shut them up. Don't tell, but Ricky has called the Dartwells up in the middle of the night and barked at them, then hung up!

"Mary Stewart and Roy stack frozen dinner trays in the tub, but Suzy Bee is getting ready for better. She goes after the dust in her bedroom with an old sock, cleans her bathroom with a toothbrush. It drives her crazy living there. Bless her heart."

Helen is not one to make fun of people. She is kind, earnest, generally good-natured, and motherly. Her lively sense of humor gives her the guilts. She laughs and apologizes in one breath. Seemed to me she had good reason to laugh and gawk. But I guess you don't want to make the neighbors into the butt of your jokes when they bring you groceries if you're sick, or help when the car breaks down out here on the rural route.

We walked along the gravel driveway the two houses share; Helen and Ricky's is a modest ranch house with a large screened porch along the front where they spend most of their free time. Pecan trees line the drive. Rotten nuts cracked beneath our feet, while the healthier ones sent us rolling.

"Got to get out here and pick through these before they all rot or break our necks. I could make a pie, but we like to eat them plain, really. You want some?"

"Yeah, thanks, I love 'em. Let's get them on the way back." Meadow grasses and blackberry vines grew thick between the two yards like an English hedge gone mad. Helen mows her lawn just to the border and shapes her side of the hedge. We went through a gate with a disintegrating wooden door dallying from its hinge. The driveway widened into a circular turnaround. Queen Anne's lace grew around the base of the pecan trees, against the garage and the house that poked out of the huge nest of stuff in the yard. We stepped over an ancient leather golf bag with the same flower, a wild carrot really, pushing its delicate head out of the split lining. What looks like one flower of Queen

Anne's lace is actually of millions of small white flowers clustered together on one stalk. All that white moved in the wind, making the yard look like a miniature blizzard. These graceful queens were throned atop their spindly stalks here at the Palace of Junk because, of course, no one mowed them down.

Helen rolled her eyes and muttered, "Don't stare directly too much. Remember we're just getting some fresh air if anyone comes out. And if they invite us in, we're not going. Don't think I'm ugly. You just had to see this."

We all have the image of southern-poor-white-trash-at-home engraved in our minds by now: bloodshot-eyed hound loafing on a rickety porch. Car parts scattered in the front yard. A heap of old toys, quilts, a ratty sofa, and cardboard boxes piled against the windows. A chunk of the roof hanging off the peeling house. Dirty kids playing barefoot in the untended flower bed and a worn-out mama standing in the door with her apron untied. A good-for-nothing-daddy tinkering with a broken tool or some piece of machinery he'll never fix. He or his uncle or his brother has a streak of drunken violence. And of course they have rotten teeth, all of them, and they live on warm tuna on very white bread, Velveeta, and Hi-C. Have I gotten that tired picture right? It's true these folks actually exist, and not just in the South—what makes southern white trash different from anywhere else, anyway? One southerner I know said even when you're trash in the South, you stick by your family. Not so elsewhere. That's what she says anyway. I'm still thinking about it.

The Palace of Junk defies easy casting. As with any generalization, something always breaks the rule, someone always makes you think again about those easy explanations you conjure for yourself about why people are they way they are. The Dartwells' place was no shack slapped together. It was once a beautiful home, as Helen said. Someone with money owned it and, according to Helen, someone with money was letting it go. The house has always been in the family, a family with good teeth and college educations. Worldly people. Helen says Mary Stewart went to a boarding school in Atlanta, goes to New

York every year to go shopping, reads all sorts of books. Roy is a whiz on the stock market. And every which way you turn Suzy Bee, she's just . . . good.

"They must have more money than most of us in town put together. They own malls and apartment buildings. She's got nice jewelry that she hauls out once in a while and they both drive fancy cars. See? She's got the Land Rover and he has the Mercedes." The cars were parked in the old hen house, which sagged dangerously close to the car roofs. They were both meticulously cared for, down to the very white walled tires. "Everything else he does is messy, but that car! Mary Stewart likes a nice car, too but she gets evil thoughts of going after Roy's car with steel wool 'cause of how he goes on about it.

"Look over there in the middle," Helen said. Where the driveway circled was an island of tufted weeds, and squat in the middle sat a Coca-Cola cooler like pharmacies and grocery stores used to have. The red in the logo was worn down to the rusting base metal. Rain water spilled over the sides. "People say they keep their money in there, sealed in freezer Baggies. It's just a story, I know. But what are they doing with a Coke cooler in the yard! I'm so embarrassed for them. Ricky and I talk about coming over here in the dark with rubber gloves on. If we ever move to Hawaii, you'll know what happened." Helen pretended to stretch dish gloves over her hands. I wanted this story to be true. Wanted the Dartwells to go all the way with their weirdness. Didn't want Helen and Ricky to end up in jail, though. Maybe the rain would bring a river of money bags to their door.

The South loves its eccentrics—conservatives, liberals, low-key, highbrow, and plain-Jane alike—even those southerners I know with the strictest ideas of how people ought to be: feminine women, manly men, church-going family people. (And if you don't go to church you ought to feel a little guilty, because you were raised in the church and know you *should* go.) People ought to be friendly, hospitable, not too personal, proud, hard-working. God knows you shouldn't be tacky, and don't take yourself too seriously. Not too intellectual—

no airs, please, but use your head and the queen's English. Be fun-loving but not crude. Be reserved and presentable and very aware of others. Behind the well-groomed yards, the Bible, the country club memberships, the jars of pickled vegetables and frozen caches of meat and fish, and even beyond the bottle, the debutantes, the silver patterns, and the china—underneath all the right appearances and manners is a hankering for drama. The eccentrics and deviants are always the protagonists of a southerner's stories. Someone who dares to do different, to do zany and be an oddball, is the star, albeit a foolish, strange, lunatic, criminal, or jackass star. The Dartwells may have posed a public health hazard, but they could keep their star route. They made too good a story.

I figure Suzy Bee was in the shower as we stood in the shadows and peered up at the sooty windows. The path to the house was a mosaic of milk cartons and cookie wrappers, spaghetti sauce jars, and a two-legged bench press. She'd probably go to college next year in Tuscaloosa or Auburn or even somewhere up north. Never come back to this tiny town again. Not unless some brave boy picked his way through the palace, took her to a football game, and married her. Otherwise Mary Stewart and Roy would load her up in the Land Rover and head out, no one outside of the county suspecting the tight fit in the hen house nor anything else.

The dogs started barking and Helen responded with a low bay. We picked up our pace and walked through the yard to the open fields. Queen Anne, with her high filigree head, unhindered by debris, had taken off and was growing everywhere. I hoped the same for Suzy Bee someday.

MAIDENHAIR FERN

ADIANTUM CAPILLUS-VENERIS

Scarlett: Maidenhair Fern, Not Quite

*H*ello, Scarlett. I see you in your little box, behind the glare of the cellophane wrapper and the shop window. Open the hinged cardboard cover, so like a book, and there you are. You have two outfits: summer and winter. You come in your sleeveless white dress with the pale green flowers, a ruffled neckline, an emerald grosgrain silk belt and parasol. A matching sash is attached to the hugely wide-brimmed straw hat tied onto your defiant little head. You are wearing a hoopskirt, but the manufacturer spared you the corset—just cinched you tightly in the middle forevermore so your owners wouldn't have to pull any strings to fit you into your clothes. It would have been a challenge to make you flexible enough to withstand all that tightening and loosening without damage. (All those faint women of the past were dizzy from their clothes more than by temperament.)

I wonder if one has to pay extra for your winter outfit. The picture on your box shows you dolled up in the velveteen dress, the one made from your draperies, of course, when you were desperate to save Tara and visited potential sugar-daddy Rhett in the Union jail. He would have none of your scheming, not yet anyway, no matter how fetching you were.

Come on out. Tell us what you're all about. Margaret Mitchell invented you but the people of the world have believed in you, made you real. Even grown women have been known to collect you, along with other internationally famous dolls, and display you in their antique living room hutches. You have become the poster child for the Southern belle. Your name is evoked any time someone (especially someone from outside the South) talks about southern femininity, as

if there were only one kind. You are cast as demure, frail, delicate, the accom-
modating mistress of the plantation. Mint juleps may as well be mainlined into
your pale arms. Your face is deceptively sweet in that box, your true nature
stuffed under that enormous hat. I watched the movie again recently. You were
a pig-headed, petulant brat. Why does anyone talk about a belle as if she were
this wan creature when we have you as an icon? You could do just about any-
thing you set your mind to, but you were perfectly awful to just about everyone
in your life, Scarlett. Why are you a heroine at all? (I admit, I've only seen the
movie, never read the book—maybe you are more likeable in the book.) You
wouldn't even take a nap on the plantation when you girls were supposed to.
Remember that scene where you all lie down to rest before the evening festivi-
ties—while the other girls followed the rules, you snuck off to try one last time
to steal Ashley's affections. Rhett caught you in the act and embarrassed you.
That's when your troubled relationship really began. He found you out, but
wanted you anyway. Sorry, but I don't have a whole lot of respect for you, my
dear; I don't like using men or social climbing. But I'll admit you were resource-
ful, persevering, indomitable when in a pinch. Come on out and defend your-
self; tell the world what makes you tick. Maybe you are too shy now, but if I
were to buy you, take you home, and give you some breathing room, surely your
sassy, tart streak would come forth and loosen your lips.

What about swashbuckling Rhett over there in his box? Stiff and mute as a
mummy, wound up smartly in his new threads—his mustache is tickling the
cellophane. You two never quite worked it out. A tragedy, really. Rhett, he was
prone to bad behavior himself, and I don't excuse him for taking you upstairs
and ravaging you, even if you did seem to like it. It gives us girls and boys the
wrong message in the end. But Clark. He wouldn't have done anything like
that. Oh to have Clark Gable's voice, albeit by cassette, in the room with me.
That would be a reason to buy this nifty two-doll package deal. Now, Scarlett,

her gilded hair

when she comes to sit down

DOLL HAIR

CAPILLUS

I have to warn you that if I bought you, you'd go the way of many a childhood doll—no special treatment. I'd style your hair till there was none left, and you'd be wearing hand-me-downs from the older dolls before you could bat your little eyelashes.

Barbie would be so jealous of all the attention you've gotten over the years. She just has plastic limbs, a tiny regulation waist, perky breasts, and permanently jacked-up heels. Many a girl has dressed her up and yanked her around town, styled her hair, lost one shoe at a time. They have imagined going on a date with Ken who picks Barbie up in a convertible Mustang (maybe a Miata these days). Popular though she may seem, Barbie will never have the allure of Miz Scarlett. Barbie is generic pin-up woman, and has no dramatic history. But Scarlett, you virtually have Spanish moss and magnolias tattooed on your cheeks; you have the Civil War in the palm of your plastic hand.

When I was young, I loved dolls (just telling you so you don't think I have a bias against dolls in general), but my mother wouldn't let me have Barbie because she was too voluptuous. I had a Jane West doll, instead. Jane West rode a fine plastic, putty-colored stallion and wore fringed jackets, blue jeans, spurs, boots, a hat with a string, all of which were cast in plastic, including fake stitch marks on the seams. She even had saddlebags and a powder compact if you wanted to dab Jane's nose between adventures. She could go anywhere and do anything. Jane, being the female counterpart of the Lone Ranger, I guess, had a sidekick whose name I can't remember. That girl had a pony and liked to borrow Jane's clothes. I'm sure there was a fight or two about that.

I also had a Tammy Doll. Tammy was a regular girl. She had curly hair and dimples, rosy cheeks and kissable red lips. She reminds me of the 1960s movie character Gidget. She had dresses with bows centered on the neckline, and a wide, colorful array of shoes. Tammy looked like she might have lifted weights in her spare time, or eaten lots of Toll-House cookies; since she was hard

rubber, it was hard to tell the difference between muscle mass and fat. Tammy looked like she lived a more realistic life than Barbie, a more pampered one than Jane. She might have even shed a tear or two in her day, volunteered at the library, earned all her Girl Scouts badges fair and square. She didn't hang out with Jane much. They were from different cliques. Unlike you Scarlett, Tammy was, in fact, a perpetual maiden. I know you started out as a maiden, as any girl does, but you have suffered a case of arrested development in the history annals. People saddle you with an inaccurate role, as I was saying earlier. You were widowed after all, not a maiden, when you bravely returned to Tara after being a wildly successful, crafty urban businesswoman. You were bedraggled by the Civil War, but not defeated. Tammy was never so chastened or challenged, and Barbie couldn't be bothered with such heavy stuff.

But these are dolls I'm talking about. Their lives were dependent upon their foster parents, those children who took them into ditches and tucked them into bed beneath blankets of leaves and ferns. And Scarlett, you were not a real woman, either, and that is ultimately my point here. I've met southern women kind of like you—women who can change a tire and wear a ball gown, renovate a house and deliver a baby, weld and knit, even play hard to get. Some of these women have a catty vein you wouldn't want to mess with. And I know others who are less like you, real women who could do all of the above if they had to, maybe, or maybe not, but who are more personable, more fun than you are. No one figure could or should symbolize southern women, no matter how much of a blockbuster the film was, how classic the novel. (I guess I'll read it soon, to see if I missed anything important before I talk myself into a corner.) If you come out of your box, it could be arranged for you to spend time with Tammy or Jane, even Barbie. Shuck your cult status, Scarlett, kick back, learn some manners, and enjoy the modern world.

Hey Look!

On the way to Birmingham from Demopolis, I'm speeding through another one of those commerceless small towns quietly wedged between hubs. The town seems to consist of makeshift churches of obscure branches of Christianity, a one-pump gas station, some small tidy homes. Someone's well-tended begonias bloom in a painted tire. Pots of fuschia hang from a stainless steel tree arching gracefully in the middle of the swept yard. There's even a bottle tree (someone has put empty bottles at the ends of branches—the belief is that evil spirits are captured in the bottles and your home is therefore safe). Whole families are out planting seeds in freshly turned gardens. The grass is an early spring green; sweet, heady honeysuckle climbs over trees and around fences. The sky is moody—it may rain. These sights could perhaps be anywhere in rural America, but then the road opens, seams of pines line the cow pastures, and you start to notice a change. There's not a cow in sight. Cars from both directions are slowing down and necks are craning. People park precariously and get out.

What is that? Sculpture in the middle of the countryside? Dozens of big round hay bales, transformed. It's a giant hay pig with fabric ears, a snout, a wire curl-of-a-tail. It's a soggy hay centipede. It's a hay spider with spindly cypress-branch legs reaching far out into the grass. A log snake or dinosaur, a hay train engine, a huge pair of cardboard scissors. A bull is charging a woman who is fleeing on legs made of hay-stuffed pantyhose. Lumpy, uncooperative stalks of hay poke through the nylon like a fractured bone or a sprung muscle. Her

blue and red smock flies behind her equally lumpy midriff—the red is why he's charging, of course. The bull is endowed with a large pair of needle-nosed, wooden horns mounted on a hay torso with weathered logs for legs. Looming over the woman is a plywood sign with a painted thought bubble reading "Olé!" Nearby is another woman with a red jumper, standing beside what looks to be a crashed rocket. The flames shooting out the back of this cone-shaped hay wreck are made of a dead Christmas tree. The woman stands in its path with another thought bubble beseeching "Call 911!" It is unclear exactly what the trouble is, but she has gotten everyone's attention, teetering inches from the barbed wire fence as she does. Hay stuffing is falling out of her disheveled body and her enormous black felt eyes stare out at us. Farmers and salespeople, families and retired vacationers congregate in front of our gal. Cameras click and heads are scratched.

Who is the artist? Does this person even consider himself or herself an artist, or is making roadside attractions just a quirky pastime? Are they made by more than one person? Did he or she or they make mock-ups out of forks and toothpicks and the salt and pepper shakers at the kitchen table one rainy day, when cooped up inside his or her Victorian ranch house that stands way out in a cattle field? It's so still, must get so dull out here in these acres of ranch land, but for this whimsical riot of hay at the fork in the road. Whoever you are, for whatever reason you make these things, don't stop.

A Bug in the Lettuce

And Other Tales from the Grave

*G*raves are stories waiting to be revealed. If family members or other people in the know weren't around to recite biographies, these stories would so easily be lost—a person's life reduced to an entry and exit date; generations of anecdotes permanently tamped away beneath earth and marble. Ever the curious traveler and lover of gossip, I recently visited several cemeteries. Here is a brief history of a region as gleaned from its graves, courtesy of my mother, father, cousins, aunts, grandmother, and other relatives.

This one was killed on the train tracks when she was running away with another woman's husband. The car broke down and she was run over. Somehow, he did not die and is buried across the row from her, with his wife. The two of them died many years later in their fifties—from the drink, I think.

This woman shot herself, we don't know why.

This woman, a girl really, died from a bug in the lettuce. My mother tells me, "They didn't have antibiotics forever, you know. They say she caught something from the bug and died that night. Stranger things have happened." My father's 1940s Boy Scouts handbook, which I recently found in my grandmother's attic, confirms the popularity of this way of thinking: in the section on personal hygiene and health, it is warned that squeezing your pimples can cause death. No pastoral, sentimental view of the old days here. If the common flu, the croup, the whooping cough, or acne didn't kill you, the bugs in the lettuce would. Maybe they still can.

LEAF SKELETON

One year the river rose to record heights and swamped the oldest section of the graveyard. Most of the graves were left intact, their carved biblical names still clearly legible: Zebadiah, Moses, Ezekiel. Weathered, wrought iron fences kept some family plots, about the size of picnic sites, in place, but one woman had wanderlust and ended up off to the side with the slaves, lone travelers, and paupers. Her simple, flat marker reads *Grave of an unknown woman who washed to shore in an iron casket in a flood, 1970s*. I picture a giant river-going teakettle or casserole, a small battleship bobbing its way up the Tombigbee River. A woman out of time is sealed in that tomb in a black dress closed at her throat, a grim pioneer's face, her hair parted in the middle and tied back in a tight bun. Her gloves and shoes are awash with buttons. When the rain finally stopped and the river relaxed, the emergency crews in their waders and Day-Glo life vests set her heavy casket to rest in the anonymous zone, separated from her family and her history forevermore.

This man was sure he was King Kong. May he rest in peace.

This man wore highwater pants pulled up to his chin every day of his life.

This man thought he saw a German U-boat coming up the Tombigbee River and called the police. They said it was the mustard gas from the first World War affecting him again. I wonder if he ever saw Hitler or Mussolini charging up-river, poor man.

These two sisters lived together for years and years, in an antebellum home that was crumbling around them. The day came when the Tyrone sisters were taken to the hospital and treated for starvation and filth. They hadn't had a proper meal in God knows how long, and couldn't see to clean themselves. The nurses gave them baths they would long remember. Well, not so long. They were buried soon after, one beside the other.

This grave tells the story of two brothers who lived in another antebellum ruin. The paint has worn off, the hobbled shutters are closed, the widow's (widowers') walk sits atop the roof like an oversized periscope. The carriage entrance is clogged with brambles; the yard is virtually knocking at the door. A cable TV dish attached to the back of the house and a barbecue grill in the driveway are the only signs that one of the brothers still lives here. Yet the brothers' graves in the neighboring cemetery—one occupied, one waiting—are beautifully marked with elegant, polished black marble. Their names, Virginus and Edgar Coates, are engraved in a fine Gothic script. A new iron gate with a tasteful acorn and oak leaf motif encloses their site. Maybe they haven't cared so much for housekeeping, but damned if they'll not have a proper grave.

tsetse fly

This man owned a hotel that everyone swore was a front for something. He bought cars and rotated them around the parking lot so it appeared he had guests. Occasionally, he wore a maid's outfit and carried a feather duster to pretend-clean the rooms. When he died, everyone came to the estate sale just to see what was inside: antiques, unused mattresses, bric-a-brac, and a vast collection of salt and pepper shakers.

Here is *Sir,* the first black man to be buried in what was formerly the whites-only cemetery. Next to him lies his wife. Their presence is a way to see small change in the South—there are no longer separate sides of the field for each race. Just husbands and wives, sisters, brothers, children, black and white, laid out together in the hot sun.

This woman wanted her dog buried with her when she died. Even if the dog wasn't dead yet, she told the family to kill it, because no one else would be able

to love that Chihuahua like she did. *Now put her on my chest when I go,* she said. Whether or not they really did it, the gravestone reads *Mary Martha and Peanut, Together Forever.*

My aunt's fresh grave. I touch the wet mound of earth and tell her good-bye. Remembering that her husband died many years before, I asked her sister why he hadn't been buried in the newer cemetery on the edge of town where the rest of us, when we went, were bound to end up. *Because he would have been the first person out there and she didn't want him to be alone.* She was alone for forty-odd years and now, here they are, side by side at last. Her potted silk flowers have fallen over; I upright them and apologize for missing her funeral. I hear her fast, plucky way of talking, her tales of growing up in the country, of teaching, of looking after me. *When you were a little tiny thing, your daddy was sick in the hospital and you stayed with me. I was fixing to change your diaper and you p-u-u-u-lled that leg back to kick me, just like this (she flexed her foot and bent her knee). I raised my palm (she raised her small pink hand) and you looked at me with a huge grin and said "Spank?" I said "Yes, ma'am," and you just laughed and laughed, just like you still do. I didn't have to spank you, Sugar, no, ma'am.* I see her German chocolate cake under a Tupperware dome—even though she was diabetic; it was for the children, minus a slice or two—her sore feet propped up on the ottoman, and her delighted, lovable grin.

My family has six plots in the new cemetery, the one off the highway, the flat parking lot for the hereafter. Grandaddy is already here, around the corner from the site of his beloved International Harvester dealership. The rest of us have reserved spots. My mother noticed on her last visit that she would rest beside Nyoka the Jungle Girl, the girl who used to live upstairs from her, who climbed the pecan tree with a knife in her teeth and swung down from the branches, the girl who used to ride her horse up the back stairs to her apartment.

Some of my ancestors are buried in a private cemetery in the country. An unmarked dirt road with a locked gate leads into the woods. I was there for my grandmother's funeral. I was seven and it was my first experience of death. A rattlesnake crouched at the base of a pine tree and watched us. I picked up one of the smooth pebbles dotting the salmon-colored mound tilled over her casket. Those two moments—snake and pebble—fused together in my recognition of what was happening: when you bury people, they return to nature, that raw, rattling, beautiful place we will all eventually go. I remember that strange, fearful awakening as clearly as I do her gumdrop tree at Christmas or her easy laughter, the way she talked with her hands fluttering and dancing in rhythm with her thoughts, her hairpins on the vanity, the bun falling free at night. Grandma has many earthly companions now. They are nestled together in a quiet dell, the people, snakes, squirrels, ants, birds . . .

And then there are the Booths, of John Wilkes lineage; they are buried out here, too. There's some talk of our being related, though I haven't tried to uncover that mystery. I prefer to think of our other famous ancestor, Edgar Allan Poe (he came to the family through adoption, not blood). Tragic though his life may have been, Poe's legacy is certainly more praiseworthy. We are connected to the Allans who are spread out under these pines. A chain-link fence surrounds everyone, whatever their deeds and accomplishments, so roaming cows won't knock the stones over anymore nor eat the thin grass and potted flowers.

There are Civil War graves of unknown soldiers in the middle of a nearby golf resort. The Southern men are buried beneath a wooden arch with Confederate Dead written in nailed-on plywood letters. Wooden crosses stand in upright rows while flat marble stones bear the Confederate insignia, and the date and battle of death. The Yankees lie outside the arch, lined up—sans cross—against a split-rail fence. Cushy green fairways and golf carts roll eerily by in the near distance.

LEAF SKELETON

Notable gravestones:

I told you I was sick

Provided for by . . . (so there would be no doubt who paid)

Gone home (with an engraved finger pointing upward)

I didn't see any fingers pointing down. That direction must be a private matter, to be determined by some force greater than the family or the stone carver. Besides, families have other things to do. They gather for Dinner on the Grounds, Singin' in the Church, otherwise known as Decoration Day, a weekend for honoring the dead and tending the graves, especially in those cemeteries that don't have Perpetual Care. It's a time to cut the grass, rake the leaves, repair headstones, and share covered dishes on picnic tables and blankets spread in the sun. While pulling weeds and righting a hinge on the fence, or sharing potato salad, people remember this and that. They recount these stories, peppering them or watering them down as they see fit. Maybe telling them differently next year or exactly the same, it doesn't really matter. It's the thought and the fresh flowers (real or artificial) that count.

The Fat Tuesday Tree

What tree is this with its bold, sunny disposition, its sweetly heart-shaped leaves, pre-teen lanky limbs, and boney trunk? The limbs are bedecked with Mardi Gras beads or doubloons, those cheap necklaces thrown from floats each February in New Orleans. People scurry in the streets to catch them. Now it's August. I've just left my hotel and am driving in a rush to the airport when the morning sun catches the jewels, ripens the shimmering, slinky faux fruits. It's an all-year party in this yard. I'll call this the Fat Tuesday Tree, even though it's really a young catalpa, a tree that likes to be out in the open and is often planted as an ornamental, yet seldom so literally as this. What was a plain, amenable tree has been dressed up and transformed into a flashy new species. A whimsical graft of things human onto a plant.

I am standing in the strangers' yard photographing the Fat Tuesday Tree when a woman down the street yells from her driveway and waves her skinny, bare arms at me: *Who are you? Come here. What are you taking pictures for? The magazines, the newspapers? And what of? Come talk to me.* Shh, I think to myself, what if you wake the merrymakers and they see me in their yard? She seems to be scolding

specimen on the next page isn't really catalpa— this is

SOUTHERN CATALPA

CATALPA BIGNONIOIDES

me. I sheepishly get in the rental car and drive up to her, roll down the window. She sticks her head in.

Hello. I am Natalie Virginia Broussard (maiden name's Vincent). Natalie's hair is a white frenzy, her eyes large and cloudy. She wears a T-shirt and stretch pants with a wide elastic waistband. Her large, drooping, braless breasts are slung toward the middle of her body and appear to be one. *Where are you from?* Vermont, most recently. *What are you taking pictures of?* That tree. *Why?* I like it. *Oh. Me, too. I grew up here. Lived my whole life in this little town. A good place. Eighty-seven and nothing wrong with me. No heart failure, not demented, not crazy. It's the sea. Seafood is good for you. I'm an antique. I even have an antique car parked under this mimosa tree.* You sure do. *Let me give you my address. I've never seen Vermont. Never gotten a postcard from there before, either. Send me a picture. Where's your husband? Bring him next time.* Okay. I'll do that.

We exchange addresses on my torn deposit slip. Natalie smiles with her fading teeth, mostly gums. I look under the mimosa tree at the antique car— a silver roadster. I imagine the mimosa festooned with its usual yellow flowers, but also with seafood, its iridescent scales and shells and baubles of white meat winking in the sun. Her car, not likely to see the road again, rusts peacefully in the salt air. Natalie Virginia Broussard and I wave good-bye. As I speed away, the Fat Tuesday Tree, ever the life of the party, dances brightly in the rearview mirror.

Queen at Last

What if I Were Someone Else?

I am this year's Mardi Gras Queen. When I've surrendered my throne to next year's queen, you can make a mannequin of me and put my outfit on display in the downtown museum like you did with all those other girls. But until then, let me present my credentials. I never thought I'd get to be queen because I wear white shoes in the dead of winter. I walk and smoke at the same time. I swear in public, and I don't always shave my legs. I certainly do not pluck my eyebrows, and I wear minimal makeup—lipstick, foundation, and mascara once in a while. I've been known to use paper clips to hem my slacks or an occasional dress. You may notice my queen's gown is made of Elvis-esque red crushed velvet. This gown is really pants. Wide, flowing pantaloons—culottes actually—that almost fooled you into thinking I had a gown on. My gold sequins are glued on, not sewn, and my shoes are rubber-soled flats. I would have worn a gown of recycled milk jugs sewn together with yarn, preschool style, if it had been more comfortable. I also thought to drill holes in the family silver, your mama's too, and what a fine dress that would have been. It would have sparkled with more luster than a plastic sequin or a glass bead. And I'd have made it myself, instead of all those ladies-in-waiting laboring over my every measurement. But this velvet number, it seems more festive somehow. Bears my name, too—my crown is made of queen Ann(e)'s lace.

I'm afraid I wouldn't be queen at all if anyone had heard me talk ugly to the king, that waxy cut-out of a man. I told him my daddy is a machinist and runs a tractor trailer store, my mama works at the dry cleaners. He said I was a shameless fraud, that I wasn't queen material. I said I was chosen fair and square. My

QUEEN ANNE'S LACE

DAUCUS CAROTA

family is full of love and that's enough for me. I am even qualified to be a member of both the United Daughters of the Confederacy and the Daughters of the American Revolution; I just never filled the paperwork out, as if any of that has anything to do with Mardi Gras or mattered to the krewe who chose me. I also told him to go to hell. A queen is chosen for her poise, intelligence, good will, and innate charm, anyway. Just how *do* they choose the king?

I didn't go to charm school. Attended public school. I was on every sports team, so I am fully capable of supporting the insect hive of clothing a queen is supposed to lug around behind and above her as she gives her kingdom that fused-finger, wrist-pivoting wave. My teeth are stained a mild yellow because I took tetracycline as a child, so my smile is not toothpaste commercial white, but I have a good sense of humor and a *friendly* smile. Even though I washed the dishes and mowed my family's yard as a young girl, I did not suffer internal injuries nor did I grow hair on my upper lip or on my palms. I built forts in the woods and I had tea parties with my dolls. I ran with a pack of boys and tittered with the girls. I have good table manners, a way with words, and am not afraid to look anyone in the eye. I am your well-rounded, salt-of-the-earth queen. I will do you right; at every ball, parade, charity function, and lavish banquet, I will make you proud, and if I don't, I welcome letters. Thank you for this honor, ladies and gentlemen. I have been daydreaming about this a long time. Thank you. Thank you.

COLORED LEAVES

Names of People

Willodean	Sister Baby
Sister	Pansy
Violet	Rose
Bobby Rae	Edwina
Dionetta (D-Netta)	Carrie May
Glenna Faye	Imadelle
Sally Ann	Betty Joyce
Bootsie	Maddie
Lurleen	Lexa
Eula	Big (Martha, Letia, Mary)
Frances	Little (Martha, Letia, Mary)
Leuna Sue	Bechette
Le Rue (from map of Paris)	Jewell
Florine	Inez
Billie	Clara Dell
Nettie Louise	Bonnie Rose
Virginia Narcissus	Ruby
Dee Dee	Drew

MALE

Poodlum	T-Tot
D'abar	Pookie
Sonny Buck	Troy Junior
Stiles	Billy Gene
Bobby Ray	Tommy Lee
C. G.	Dewey
Nathaniel	Archibald
Buddy	Sonny
Butch	Red
Bootsie	Big (George, Henry, Pat)
Vernard	Little (George, Henry, Pat)
Francis	Gene Ray
Reece	Germaine
Merton	Dee
Boo Tyler	Brother
Atlas	Johnson
Spatula	Bryce
Caldwell	Baylor

Towns with Good Names

Burnt Corn	Why Not
Snoddy	Scooba
Coffeeville	Ballplay
Bug Tussle	Normal
The Bottle	Vinegar Bend
Enterprise	False River
Mix	Mound Bayou
Tip Top	SoSo
Smut Eye	Perote
Lower Peach Tree	Beaver Creek
Pine Apple	Rolling Fork
Alligator	Waterproof
Good Water	Sunny South
Zip City	Rash
Rough Log	Rabbit Town
Wedowee	Six Mile
Palestine	Wren
Drag	Wait
Hollywood	Malcolm
Allgood	Akbachoochee
Coy	Murder Creek
Tuscaloosa	Good Hope
Eufaula	Dog Town

Cusseta
Yazoo City
Chunky
Pascagoula
Pigeon
Wyandotte
Natchitoches
Many
Big Cane
White Castle
Cut Off
Triumph
Wax
Eulonia
Enigma
The Rock
Experiment
Fairplay
Cotton

Reform
Ten Mile
Leaf
Bogalusa
Houma
Opelousas
Eunice
Oil City
Catahoula
Happy Jack
Thibodaux
Cairo
Welcome
Willacoochee
Milledgeville
Ideal
Benevolence
Opelika

Names of Establishments

Jitney Jungle

Pig's

Jazz's Grocery

BA's House of Stylz

Mean Lean Disco

Bo-Ro Family Restaurant

Old Trashpile Road

Justin's Observatory

The Mug and Cone

Mammy's Cupboard

The Gin

Onward Store

Puddin Place

The Everyday Gourmet

Catfish Shak

Doe's

Creative Loafing

Ava Maria Grotto

Medric Martin Grocery

Shadows on the Teche

Dipsey Doodle Club

Bruce's U-Need-a-Butcher

Dup's Lounge

Basketcase

Mama's Fried Chicken

Piggly Wiggly

Daddy Man's

Big Man

Delta Soul House

Grown William's Road

Boiling Point

Yellow Bowl

Jr.'s Food Store

Night Spot

Bottletree Bakery

Hoka

Daddy's Money

Smitty's

Rock City

Cock of the Walk

Uncle Henry's

Kudzu Kings

Vulcan Park

Le Beau Petit Musée

Bird City

Double D Cotton Club

Top End

Smiley's Bon Amie

Uncle Buck's

Swamp Dog

Superstitions and Sayings

A Small Sample

Never walk with one shoe on and one shoe off. Every step you take will bring
 a year of bad luck.

Never put a hat on the bed. Bad luck.

Don't tell a nightmare before breakfast, or it will come true.

Never give someone a knife or a sharp object as a gift, or you'll sever the
 relationship—unless the recipient sends the giver a quarter in exchange.

Anytime a rabbit passes in the road, tip your hat and say "How do, Mr.
 Rabbit?" Good manners mostly. Good luck.

If you sing before breakfast, you'll cry before supper.

Don't laugh when the hearse goes by, because you may be the next to die.

If you see a white mule, kiss your thumb and stamp your feet for good luck.

It's cool as a cucumber.

He doesn't have the sense God gave green apples.

I swanny. (Said instead of taking the Lord's name in vain.)

She's so cruddy, or, she's a crud. (She's got no couth, is messy, or immoral.)

It's hot as Hades.

If it's raining and the sun's shining, the devil is beating his wife.

I'm not fit to drive a hen from the door. (Really sick.)

Sorry as a worn-out shoe.

An idle brain is the devil's workshop.

When I sit down, my mind sits down with me.

Always enter and leave through the same door.

Never take white flowers to a sick person. Bad luck.

Don't kill a daddy-long-legs. Bad luck.

If you drop a piece of silverware, someone's coming to visit.

Letting your biscuits burn means you are angry.

If your right hand itches, you will get some money; if your left hand itches, you'll get a letter.

Cover the mirrors when someone dies, or it's bad luck: the mirrors will never be clear again or someone else will die soon. Also, stop the clocks.

When someone dies, go tell the bees so they won't go away, too.

Always eat black-eyed peas on New Year's Day. You'll have plenty to eat all year.

If you don't want an unwelcome visitor to come back, sweep behind him when he goes.

If you eat too fast, you'll marry too young.

Rocking an empty chair brings bad luck.

Carrying a buckeye in your pocket brings good luck.

Whatever you dream the first night in a new house will come true.

If you put someone's hair in your locket, they'll love you forever.

Don't call the alligator ugly till you've crossed the river.

LONE WHITE FLOWER

Acknowledgments

Despite the title of the art heading this roster of thanks, there is no such thing as a lone flower, not in nature and not in the making of this book. As a flower needs sun, air, neighboring plants, and creatures, so too does a writer and artist need other people. I would like to express my gratitude to those who helped me write this book.

First, I want to thank my parents, Ralph and Clara Lewis, for their love and generosity, their appreciation of a good story, and their fabulous senses of humor. Also, they should be commended for their patience in answering the oddest array of questions a daughter could throw their way: *Daddy, would a chicken farmer ever slit a chicken down the middle, leave its feathers on, and truck it unrefrigerated to the plucker? Mother, why didn't you let me play with Barbie? Did you tease your hair in 1969? Why can't you walk with one shoe on and one shoe off?*

I'd also like to thank Grandma Lewis for her love, Allison Lewis Bennett for being such an inspiration, and the rest of my southern family for always leaving the door open and warmly inviting me in; in particular, thanks to Gordon and Gail Gary and Waynê Bennett for roaming around with me; and to James Bouler Jr. for hours of fun and good talk. As for the northern kin, thanks for cheering me on.

And, of course, a book would not be a book without the behind-the-scenes people. I am grateful to everyone at Chronicle Books, especially my beloved editor Annie Barrows, Karen Silver, Lindsay Anderson, Leslie Jonath, Pamela Geismar, and Anne Hayes. I am also indebted to a host of others: the photographer, Sibila Savage, Ginny Hair, Lisa Michaels, Mandy Dowd, Nadine Bouler,

Madeleine Kahn, Emily Shepard, Britta Kathmeyer, Susan Griffin, Sheila Ballantyne, Diana O'Hehir, Cecile Pineda, Elizabeth Barash, Marcella Friel, Aurelie Sheehan, Deidre Freeman, Peggy Conant, Dominic Roques, Sue Dunham, Merrick Hamilton, Jim Paul, and especially Karen Schaffman for her long-standing friendship and keen eye. And as for Tim, the intrepid traveler, cook, soothsayer, editor, and friend, thank you for going south with me. I apologize for waking you in the middle of the night to show you a piece of art or to read a passage from THE BOOK. You're more than swell.

And to all of you I met along the way, I appreciate your interest in this project. If anyone sees themselves in these pages, know that while I may have borrowed something essential from you, I made fiction of you in the end. Your famous hospitality was not lost on me. Thanks for deepening my appreciation of the South.

Particularly valuable resources were the *Audubon Society Field Guides to North American Wildflowers* and *North American Trees; Womenfolks: Growing Up Down South* by Shirley Abbott; *Reckon Magazine: The Magazine of Southern Culture; The Encyclopedia of Southern Culture,* edited by Charles Reagan Wilson and William Ferris; *The Southern Register,* the newsletter of the Center for the Study of Southern Culture at the University of Mississippi; *The Southern Quarterly: A Journal of the Arts of the South* at the University of Southern Mississippi.

Lastly, I'd like to acknowledge the many family members who died while I was writing this book; *Confederate Jasmine and the Fat Tuesday Tree* came very close to following the dark, southern Gothic tradition. Good-bye to Aunt Billie Bouler, Aunt Dot Bridgewater, Geoffrey Stokes, Asher Moore, and David Gordon. We'll miss you.